FOUNDING FARMS

FOUNDING FARMS

Portraits of Five Massachusetts Family Farms

Photographs by Stan Sherer

Profiles by Michael E. C. Gery

The University of Massachusetts Press

AMHERST

Copyright © 1993 by The University of Massachusetts Press

All rights reserved

Printed in the United States of America

LC 91-39833

ISBN 0-87023-790-X (cloth); 791-8(pbk.)

Designed by Jack Harrison

Set in Adobe Garamond

Printed and bound by Excelsior Printing Company

Library of Congress Cataloging-in-Publication Data

Sherer, Stan, 1947-

Founding farms: portraits of five Massachusetts family farms / photographs
by Stan Sherer; profiles by Michael E.C. Gery.

 p. cm.

Includes bibliographical references.

ISBN 0-87023-790-X (alk. paper).

ISBN 0-87023-791-8 (pbk. alk.paper)

1. Family farms—Massachusetts—Pictoral works. I. Title.

HD1476.U6M47 1992 91-39833

338. 1'6—dc20

British Library Cataloguing in Publication data are available.

Contents

Foreword

Decade by decade, the United States counts fewer farms, and the number in Massachusetts has been shrinking rapidly. Farm life is becoming a matter of history books and dead metaphors in the language of urbanites. Yet some Massachusetts farms continue to function as both homes and productive economic units. The factories in the field that provide the agricultural surplus supporting industrialized society are not typical of the Commonwealth. Here the pattern is one of mixed farming with considerable reliance on customers in neighboring urban areas.

The "Founding Farms" in this book have been in the same families for more than two, in most cases more than three, centuries. Those who live on them presumably have a sense of place which counteracts some of American society's stress on the importance of time. Family legends are more memorable because they can be tied to an exact spot in a yard or field, a building, or a tool preserved even though no longer used. Both Stan Sherer's photographs and Michael Gery's interviews reveal the interworkings of place and time. Here are pictures and words that invite us into other lives. We have here a chance to learn more about life's possibilities, especially human relationships with

geographical space and human ways of accepting the past without being imprisoned by it.

These photographs show Sherer's skill in capturing "a presence." But within them is evidence of time's passage. A rusting storage tank, the wrinkles in a face, the accumulation of papers in a desk's pigeonholes, or the presence of earlier photographs on a table—all these remind the viewer of change. The farm landscapes we admire represent the work of generations in clearing stones, building barns, cutting some trees, planting others. We are not looking at wilderness, but at the results of human impulses toward order. The very contours of the land have been changed by human design, sometimes within living memory.

It is good to see a newly made patchwork quilt and its maker, reassuring evidence that a craft created by American women is still practiced. A great-grandmother's tenderness recalls generations of care for descendants. The orchard ladder represents skilled craftsmanship, not mass production. But the presence on a farmer's desk of an electronic calculator warns against sentimentality and reminds us of technological advances and economic necessities.

Among the variant mythologies of American individualism, the frontier yeoman farmer has held a prominent place. These surviving farms of Massachusetts, however, reveal other sorts of Americans and other sorts of farmers. Within these families, at least some in each generation did not head west or for the city, choosing instead to stay put. But Michael Gery's interviews help puncture a too-ready counter-stereotype. A professional career in a city helped preserve one of these ancestral farms. The manager of that farm has come east from Wisconsin to Massachusetts to pursue his chosen calling. One active farmer lived in California for a time and then returned to the Pioneer Valley. Many of the men and women pictured here hold or have held "a job in town."

The experiences of the people in these photographs, who persistently work with growing plants and animals, differ from those of apartment dwellers and suburbanites who take care of house plants or a small garden or a single pet. The talk of these farm families resonates with satisfaction in their understanding of how things grow. It is easy to think of these as ideal lives in which one stays close to nature, is one's own boss, and doesn't work for a paycheck. But a romanticized view inevitably distorts. The interviews, and to some extent the pictures, demonstrate that these farmers know, and need to know, about balance sheets, labor markets, zoning regulations, taxation, and government crop subsidies, even about international exchange rates. Their relations with "nature" are more often than not socially mediated. Our interdependent world is their world too.

None of these farms is more than an hour from a sizable city. Most are closer. In the automobile age, most Massachusetts citizens have seen such farms, but usually only as a blur of "scenery." Residents of these farms generally express satisfaction in the pleasure their farms give the rest of us. Some of them admit that it feels good to let other people see open space, eat products the day they are harvested, and talk with a person who helped raise those very crops. "Pick-your-own" has economic advantages for a landowner, but this form of selling brings more than material satisfactions to George Barker.

Of the people who see her open, productive land, Joan Appleton says, "They get more vision." They do if they will open their eyes and look. This work proves that it can be done.

HUGH HAWKINS
Professor of American Studies
Amherst College

Preface

The land-grant mission of the University of Massachusetts at Amherst for more than 125 years has sent university research to the farming community for the benefit of the Commonwealth. The "Founding Farms" project has followed that tradition. But instead of sending information from the university to the farmers, we hope to impart an understanding of farmers and farming to the Commonwealth at large. We pursued the work as journalists from the University of Massachusetts.

Massachusetts family farms are among the oldest in the United States. From the Merrimack Valley to the Berkshire Hills, the Commonwealth's soils have given sustenance to its people and to the world for more than 300 years.

The families who tend the Commonwealth's oldest farms have nourished the state's culture as well. Their names and deeds appear in the early chapters of town histories. While founding our farms, they established our town governments, schools, and churches, our town commons, business centers, and open landscapes. They began and sustained local traditions carried on throughout Massachusetts.

As we close the twentieth century, we are watching Massachusetts family farms close as well. Since 1950, Massachusetts has lost 80 percent of its farms. Farming may be a desirable way of life, but it is no longer a favorable one. As others before them, Massachusetts farms succumb to economic fatigue and to communities which have crowded them out.

The farm families who remain can tell us what it means and how it feels to sound the chord of history simply by living as they know best. They attend not only to growing food for the rest of us, but also to passing their land and way of life to succeeding generations.

The people who appear in these portraits are devoted to farming as a livelihood in spite of the difficulties of such work in Massachusetts. They love land and agriculture. They know, respect, and preserve our region's natural heritage. We chose three of the oldest farms in eastern Massachusetts and two of the oldest in western Massachusetts to illustrate the regional differences.

A portion of these photographs and profiles appeared in an exhibition mounted in museums and galleries across Massachusetts in 1990 and 1991. The "Founding Farms" photographic exhibit and catalog were made possible in part by grants from the University of Massachusetts Public Service Endowment, the Massachusetts Foundation for the Humanities, the Abbot and Dorothy H. Stevens Foundation of North Andover, Eastman Kodak Company's Professional Photography Division, the Northampton Arts Lottery Council, and Ocean Spray Cranberries, Inc. Any errors that appear are ours alone. Any changes that have occurred on the farms since we last visited are signs of progress which we have been unable to record.

We would like to thank the Vice Chancellory for University Relations and Development at the University of Massachusetts at Amherst, Christine Davies, and David Glassberg for their continuing encouragement.

We are especially grateful to the families portrayed here. They graciously welcomed us to their farms to photograph, interview, and visit. We appreciate what they have given to our communities and to the Commonwealth.

FOUNDING FARMS

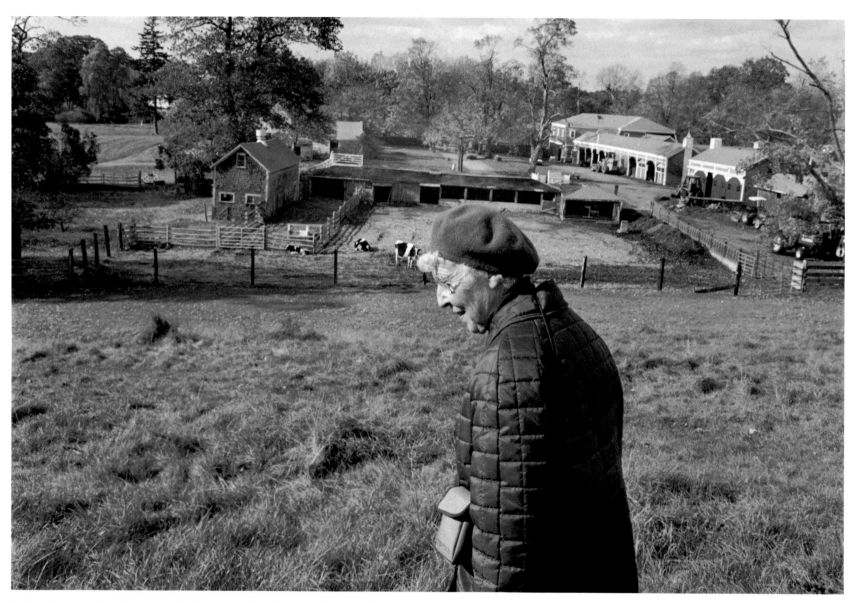

There's something about productive, open land. It reaches people. It strikes a chord, and they get more vision.—JOAN APPLETON

Appleton Farm

IPSWICH
Founded in 1638

When Samuel Appleton left the fold at Little Waldingfield to go to the colonies in 1638, they called him "the Emigrant." He had ventured 100 pounds with the Winthrop Company toward 460 acres in the Massachusetts Bay colony. At the age of forty-nine, Appleton sailed with his second wife and six children to America and there they joined their English neighbors the Winthrops to settle among the Indians, wolves, and salt marshes of the territory which is now Ipswich. The plantation he established would become one of the preeminent farm estates in New England.

Today, Appleton Farms is the oldest farm in Massachusetts. Even in the 1830s, the town of Ipswich could proudly claim a magnificent farm that had survived in a single family for two centuries. It remains a source of pride to the town, to the Commonwealth, to the many descendants of the Appletons, and to Joan Egleston Appleton. Before Mrs. Appleton's husband died in

1974, the two of them agreed to do all they could to maintain the 1,000-acre estate as a farm. And so it has remained.

Into the 1990s now, the Appleton farm estate is passing from the Appleton family. With no children to leave it to, Joan Appleton has made arrangements to transfer the farm enterprise to James and Caroline Geiger who came to it as farm managers in 1979. James Geiger is a young entrepreneurial farmer who in ten years sent Appleton Farms to the forefront of the dairy-cow embryo business. The business is now selling the offspring of a high-producing Holstein for between $10,000 and $20,000 each.

Eventually, the farm's land will go to the Trustees of Reservations, the 100-year-old Massachusetts conservancy which also has custody of the nearby 1,400-acre Crane Beach. For as far into the future as anyone cares to plan at the moment, Appleton Farms will continue with the Appleton name, as well as in the family tradition of productive agriculture in Ipswich. The grounds will be open on a limited basis so that visitors can glimpse the legacy of a farm which one family was determined to preserve for more than 350 years.

A 1638 town register records the grant of land to Samuel Appleton the Emigrant as "a farme containing foure hundred and sixty acres, more or less, medow and upland as it lyeth." A survey in 1901, however, determined some 770 acres of land in that grant. Besides producing garden vegetables, corn, and hay, Samuel, the first Appleton in America, had a corner on the local market in malt beverages. As a maltster, he was granted a five-year monopoly by the town authorities. Records also show that he grazed cattle on common land, a practice which continued as long as there were wolves to contend with in the still-wooded areas surrounding seventeenth-century farms.

The Emigrant's fifth child, Samuel, took over the farm in the late 1600s. Though he had a house in the center of town, he preferred the farm. But Major Samuel, as he was known, was more famous for his military and political courage. He commanded the Massachusetts forces victoriously in the western part of the colony against the Indian chief King Philip in the 1670s. Later, the royal colonial governor jailed this Samuel for sedition, but, according to family history, Samuel lived to escort the governor himself to jail.

In the 1700s, once the Ipswich Appletons had grown short of land to divide among themselves, sons and daughters moved on to prominence in New Hampshire, Boston, New York, and elsewhere. But there was always a son to carry on the farm just outside of town. Through the nineteenth century, the Appleton farm carried on a lively local trade in meat, wool, hides, butter and cheese, vegetables, grains, and wood. In 1839, the family gave the Eastern Railroad a right-of-way through the Ipswich estate, after Eastern agreed to redraw the course to avoid the main house. The train that Henry Thoreau knew in Concord used this roadbed, and the commuter train to Boston uses it today.

A hundred years ago, Appleton Farms was among the most prosperous farms in the country. Daniel Fuller Appleton succeeded his father in regaining the Ipswich farmlands which had been transferred to others in the previous generations. It was this Appleton who, in the opinion of James Geiger today, accomplished the most improvement at the farmstead. The mid-1860s marked the ascendance of the dairy industry at Appleton farm. Adequate transportation and protection against disease allowed farms to produce milk for more than local use. Daniel Fuller Appleton sent the farm into the dairy-cattle breeding business at this time, and it would remain in the forefront for more than a hundred years. He also instituted drainage improvements in the

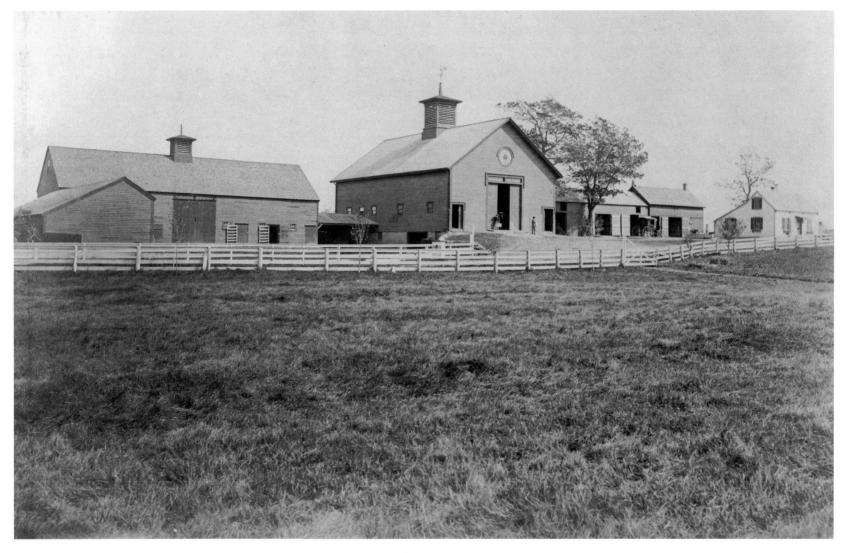

The Appleton farm buildings in 1892

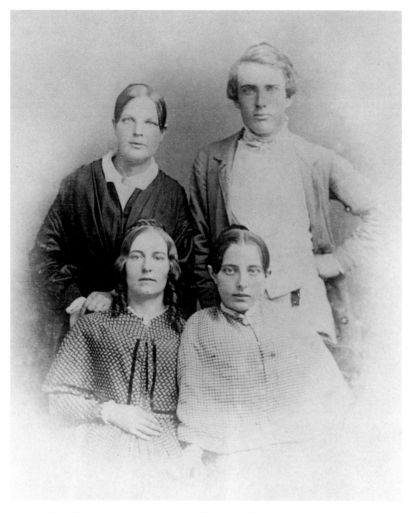

Daniel Fullerton Appleton, grandfather of Francis R. Appleton, Jr., with other family members

pastures by installing buried tiles, a change which greatly increased the hay yield. And by 1890, the farm had bred a Jersey cow that produced a world's record 945 pounds, nine ounces of butter. The cow, named "Eurotisama," weighed 820 pounds and ate twenty-four pounds of grain per day.

Daniel Fuller Appleton's son, Francis R. Appleton, is described by Thomas Franklin Waters in his 1917 history of Ipswich as "lately an Overseer of Harvard University, President of the Harvard Club in New York City, Vice-President of the Waltham Watch Company, and Director of the Cape Cod Canal Corporation." In Ipswich, Francis repossessed even more family lands, rebuilt all the farm buildings, lined the avenues with maple and elm trees, and bred world-record Holsteins.

Francis R. Appleton, Jr., after attending Harvard, served in World War I as a lieutenant colonel. He would be known as Colonel Appleton in Ipswich. When he assumed the farm in 1929, he already was practicing international law in New York City with Appleton, Rice & Perrin on Wall Street. But he would return as often as he could to Ipswich where he met, and later married, Joan Egleston. It could not have been a more fortuitous meeting for the sake of Appleton Farms.

Joan Egleston Appleton fulfills all the glory of this farm. All her happiness has been here, comforted by animals and elm trees, high windows and family portraits. For fifty years she has eschewed a life of tipping teacups in the parlors of Boston or New York in favor of feeding her horses before dawn, then riding the dales into the woods. "I've always loved land and farming," she said in the fall of 1989. "It is to me the ideal sort of life."

When she first saw the place, Appleton Farms was at its aristocratic best. Louis Bromfield, married to an Appleton relative, described the goings on in his 1924 Pulitzer Prize–winning ro-

mance novel *Early Autumn*. It was a place with a forty-room main house and nearby cottages; a place with servants and field hands, fox hunts and grand balls.

Though her ancestors were American, Joan Egleston's father was born in England, as was she. You can hear it in her proper and polite tone. And her eyes gleam, too, as she remembers those early autumn days when she went abroad to America.

I was at the Winthrop place, two miles away as the crow flies. The Appletons were my cousins, and I put off for a long time visiting them, because I didn't like having to go and visit relations. Then one day my cousin, Frank Appleton, appeared on his horse. I was out riding, and we rode together. And one thing led to another.

I used to go around with him on foot or on horseback and look at the stock, and we just talked things over. Then when we got married, we did the same thing. We would discuss things and decide to go into Hereford cows or Shropshire sheep or whatever it happened to be.

And he was always busy landscaping, as well as taking care of the agriculture, as his father before him had been, very keen. They'd always been keen, as you can see from the way things have been laid out in the way of these avenues of trees. They didn't get there by themselves!

The trees are beautiful. You can see them from Route 1A, across the broad grass fields where you might see wild geese, too. The trees stand like old and stolid sentries, about a mile of them, along the entrance road as it approaches the barns and the houses. People drive along the highway just to see this view and wonder what goes on there and what has gone on there. Those trees certainly did not get there by themselves. And the fields did not get there by themselves, either. Colonel Appleton and Joan carried the farm through the Great Depression and into the

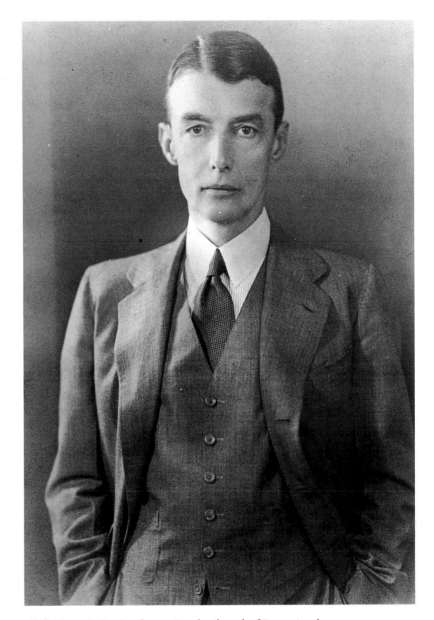

Col. Francis R. Appleton, Jr., husband of Joan Appleton, 1939

1940s. Local labor was plentiful and affordable, and the Appletons could enjoy it, Joan remembers.

In those days, you paid—what?—about three dollars a day for the different laborers who would walk in from Ipswich along the tracks, work all day, and walk home at night, having had their lunch in a brown paper bag. And happy to do it! They loved their teams of horses, they loved the stock. And very often their sons or daughters came here and went on working on the farm. There have been people who worked here thirty, forty years. We still have the former herdsman here that long. But he is really very much retired, so he's living here. He's got a wonderful hindsight that's enormously helpful to call on every now and again.

The first thing Francis Jr. did in 1929 was to buy six Guernsey cows to begin what would become the most famous of the acclaimed "North Shore" Guernsey herds of the 1940s. Milk would flow from the Colonel's Guernsey farm for the next fifty years. Fearing disease that might come from purchased cattle, the Appletons began to breed their own cows in 1939. They had by that time introduced Herefords to the farm, and so continued with that line. Mrs. Appleton had a great fondness for all the animals.

When I first came here, we had Poland China pigs. They are huge, great things, black and white fellows. We had a large quantity of those. Then we had white Holland turkeys. Our manager, who was a boy on this farm, then became manager, and his consort — she wasn't his wife, because he couldn't get his wife over from Poland — they just really loved raising turkey polts, and moaning and crowing when diseases struck, which they did constantly, 'til better medicines came along to try to keep the little turkey dears alive.

We have had various breeds of sheep, not always at the same time. It depended on the markets. It depended on what was available or what we thought we wanted to do with the pastures, to rotate them.

Otherwise, we were constantly trying to see what we could do to improve the pastures, the drainage, and so forth.

In the 1930s, they overhauled the 135-acre Great Pasture, the summer feeding ground for the cattle. Colonel Appleton's father had intended to complete the overhaul himself, but had never actually made the improvement. James Geiger writes in his 1988 agricultural history of the farm that the Great Pasture was Colonel Appleton's most significant contribution to the place. It was indeed a major undertaking. The pasture, Geiger writes, was "grubbed of grey birch and scrub trees and roots, cleared of rocks, plowed, and finally laid to a mixture of chewings fescue, bird's-foot trefoil, bluegrass and Kents wild white creeping imported clover."

As the nation went to war again, the local supply of male farmhands became less abundant. Joan Appleton left Ipswich for a period to work with the Red Cross, but the majority of her time was spent on the farm. She was there in the summer of 1943 when an afternoon storm set horrific fire to the barns, including a barn built in 1696 and a big new silo.

We did have girls working here and staying here, and we did do a lot of work. It was on one of those awful times when the main barn burned, the new barn that we'd just done over. It was the day that we just got in an enormous amount of—was it barley or was it oats? I can't quite remember. It was one or the other. And all of a sudden, you know, the headers just hit—BANG!—in the middle of the barn. The cows were out, fortunately, but all the men and everybody at that time had gone back to Ipswich. The girls and I had to get the heavy

horses out of the barn and try to keep things all right. The whole farm nearly went up, because the wind kept shifting. This house got so hot, you wouldn't believe it. The other houses had ashes all over them. That was a very unpleasant experience.

The next morning, there was no way to milk the cows. So the tragedy of all that was that the kind farmer neighbors came along in and milked the cows, tied to fences and so on, and we got the biggest infection of mastitis that has ever been known here, and pretty nearly lost a herd. But you know, they were very kind and very nice, but they came from dirty herds, and that was that.

By the end of the 1940s the Appletons looked over about 170 cattle, 130 sheep, 950 turkeys, and 35 pigs. Many of these animals would be shipped in railroad cars to market via the Boston and Maine Railroad, which had taken over the line which passes through the farm.

Frank Appleton was in New York a good deal of the time. There he proudly served as an officer of the club called the New York Farmers. They were what you would call gentleman farmers. Many of them enjoyed the bounty of the Appleton farm because several meetings were held there. Joan recalls how things would work in those days, which in one manner or another continued into the 1970s.

I had to live a certain amount of time in New York, which wasn't exactly what I liked at all. But he was a lawyer, and he needed his outside income to a certain extent to help keep these lands going.

I had to run a house and do a certain amount of entertaining of farmers, or nonfarmers, or whatever you want to call them. My husband was an officer in the New York Farmers. When we were in New York, he served as secretary of the New York Farmers for many years. So there were always those sort of things that had to be attended

There was a tremendous determination here and a great love and tradition for the place. All the Appletons felt it was worthwhile.
—JOAN APPLETON

to. We directed it here. And in those days, there were very nice people called secretaries, who got you out many copies of things and so on.

We would do this horrible commute between here and New York. We would come up and make sure everything was going all right and, of course, get reports all the time. We came back and forth pretty hard. It's a heck of an awful long way by car. I can't remember just how we drove. We went all wiggly-wiggly. Took half the day, at least, in a huge old Packard which we had, sort of an open-air Packard, swarming with dogs, back and forth. It wasn't my idea of bliss by a long shot, but if you wanted to keep an eye on the farm, that was the only way we could do it.

When her husband died in 1974, Joan Appleton, along with the longtime herdsman and his crew, presided over the farm's most recent "resting period." Mrs. Appleton kept horses, dairy cattle, and some sheep, and she developed a herd of beefalo. Otherwise she kept the farm in order until James and Caroline Geiger moved onto the place in 1979. And now it has resumed its prominence among the great bovine farms of the region.

As for the future of the farm, Joan Appleton and her husband agreed to do what they could to keep it a farm. Rejecting offers from developers and sporting clubs has been constant, difficult as it is in a territory where land sells for $100,000 an acre. But the place will stay open, as it has for years, to people who want to walk in the 200 acres of woods, or ride horses on the "Grass Rides." As Mrs. Appleton explains, the Trustees of Reservations will assure that the farming is not disrupted, but may allow people to see a farm and the surrounding lands that make it a farm.

It's not easy in this area, because a lot of people would like to use one's land for purposes other than farming. I'm not talking about using it for real estate, though one gets plenty of those. But one gets quite used to saying, "Well, no, you'd better go elsewhere. This land is going to be protected one way or another." But there are other interests, recreation-wise, who'd like to use the land. I have been quite firm about trying to keep it for the wildlife and for those that live on it and for the stock, in general.

There's something about productive, open land. It reaches people. It strikes a chord, and they get more vision. It does seem to uplift people. I've noticed that even out in the woodlands. My husband and I were both quite vigorous in trying to keep snowmobiles, or any motorized vehicles, out of the woods. Then there would be a place where people can go. It's very, very beautiful out there, actually. They can get in and relax and have their children with them and not have motorbikes or horses jumping all over them. They can browse around and enjoy the beauty. I've had many, many letters from people expressing their happiness that they could do that.

* * *

Growing up in the 1950s and 1960s in a small town near Madison, Wisconsin, James Geiger held a prejudice for estate farms owned by people who weren't real farmers, mainly because he wanted to be a real farmer. His home was not a farm, but his grandfather's was, and James loved it there.

When I was of age, twenty to twenty-two years old, the problem was that farmland prices were just sky-high in Wisconsin. And that was really a troubling time for agriculture, because unless you inherited a farm, you weren't going to get involved in farming in Wisconsin.

He and his wife, Caroline, came to New England and worked on farms, first an organic beef farm, then a dairy farm. He met

Mrs. Appleton in 1978 and eventually took over as manager of Appleton Farms, Inc.

Mrs. Appleton has had a completely different sort of background than I have. But I developed a lot of respect for her as an individual and the way she approached things, and her attitudes towards farming and her attitudes towards respecting other people's abilities. If you combine that with the raw potential that any farmer could see sitting here, it wasn't too hard to decide that we would like to work here.

The Geigers now feel their own strong attachment to the Appleton place. Their two children are growing up on the farm. James has studied the farm and recently wrote a monograph of its 350-year agricultural history. He is a methodical, articulate man who obviously enjoys just roaming the Great Pasture, on foot or in the jeep, smoking a pipe, or stroking cattle.

The first thing James Geiger did as manager of Appleton Farms was to reestablish the Appleton dairy herd. But he knew he would have to do more than that. He studied cheesemaking, thinking it was a compatible enterprise that would favor the balance sheet. "And it's just one of those honorable professions," he says. "But it seemed very complicated, and it seemed like we needed more capital investment. I could see that the labor problems were increasing. So that made me wonder who was going to make the cheese when the cheese-maker called in sick."

Meanwhile, he grew a young cow in the tradition of Appleton Farms. "Valiant Bordeaux" became what they call a "premier performer," whose production placed her in the top two percent of all Holsteins in the nation. People noticed. They were interested in her genes. So James Geiger learned fast about getting the cow to ovulate more frequently. He would then transfer her embryos to other cows and sell the calves, or the embryos themselves.

Reading all he could about the business of cow embryo transfer technology, James figured he could make a go of it. He would sell investment shares in the supercow. "That was a whole different thing, selling securities," he remembers. "That was a period of time that was pretty intense for me. That's very different than farming." It took him close to a year to sell subscriptions to form his first limited partnership, which, with him as general partner, would own, tend, and sell a cow's ability to deliver genetically great calves.

While forming a second partnership in 1985, James learned about "Juniper-Mist Bell Paula," who was producing twice as much milk as the average Holstein. The Appleton Farms partnership bought her and some of her embryos for $125,000. She soon rose to the ninth position on the Holstein Association's Premier Performer List. One year she had twenty-four pregnancies. By the end of 1987, Bell Paula claimed more than fifty offspring somewhere "on the ground," as they say, in the United States and overseas. She is in fact a world-famous cow at age eight. Appleton Farms shipped one of her bull calves to Japan in 1989 and received $20,000 for him. Her females cost about $10,000. And these offspring have become supercows themselves. Buyers are lined up waiting for her to ovulate. As it happened in 1989, Bell Paula left them waiting. She was "on vacation" most of the year, as James says. Appleton Farms has bought a successor, a three-year-old named "Mark Doris." She cost almost $30,000. Already she has reached the sixth position on the Holstein Association's New England list.

"I don't take any credit for this, because it's her," James Geiger says. "It's Bell Paula."

When we first came here, we had the National Holstein convention

here in New England one year, and I said to everybody working here, "Come on now. Let's get things shaped up, because I want some visitors at this farm this year." And we did. We had things really shaped up well. We had a 20,000-pound herd average, led the county and all that, and were very proud of our accomplishments there. That was something that I got great satisfaction out of, making a herd of cows perform. It's just that when it continually doesn't pay the bills, you realize that if you're a gentleman farmer, you can do that, but if you're trying to make a living, you can't. So it wasn't until I bought Bell Paula that the telephone started ringing.

People started flying into Boston just to come and see Bell Paula. People started flying into Beverly to pick me up, to take me to a sale where they were going to buy one of her offspring. . . . When you're dealing with foreign buyers, they come here. They come here, because they want to see what they're buying, for the most part. You just try to get on with them, that's all. . . . It just started happening. It didn't have anything to do with my approach; it just happened because I had the product.

Then it just became standard, advertising in the breed journals and that sort of thing. We tried to be somewhat creative about it, placing them in the right sales.

The embryo enterprise accounts for about three-quarters of Appleton Farms, Inc. income. Half of the offspring are sold to buyers outside the United States, mostly in France and Japan. But James Geiger believes it won't be long until herds there are developed, and there will be plenty of supercows around. At one point he thought China might be a good market. But his skepticism about dealing with the Chinese government was confirmed during its forcible oppression of the prodemocracy demonstrations in the spring of 1989.

I had been really interested in starting something in China, and I wasn't terribly surprised [about the crackdown in Tienanmen Square], because I had studied it. I thought that our next move in terms of marketing was going to be, in fact, to have a production facility in China tied in with our genetics business.

I took a couple of agri-business courses down in Cambridge and started using the library at the Harvard Business School. I started reading about how the Chinese government was dealing with business people. You've got to get through all that stuff on the surface, where they've got these open hands and say "Do business with us." Of course, Chinese people are delightful people, but their government! I read a story about foreign investors who had their brood sow operation there, and because of circumstances, the Chinese government won't own up to the fact that in China there is this particular disease, so you can't vaccinate those sows before you take them in, because they say they don't have the disease, even though everybody knows they do. When the investors' sows got the disease, the Chinese Army came in and slaughtered about a million dollars worth of brood sows without asking permission. When I read that, I said, "This may be more risky than I hoped for."

I think that you're just simply dealing with a window in the international market for genetics. Once Germany and Japan have skimmed the cream off our genetic crop sufficiently, they'll be our primary competitors. Who do you think is going to do a better job of marketing? I really believe that. I think it will go on for a while, but I wouldn't want to plan for that to be my primary business. It could change very quickly. And it's subject to all these international things, you know. What goes on at the GATT [General Agreement on Tariffs and Trade] talks are of great interest to me because of that. You could get the Japanese or the French turned off very easily. Or, somebody in Washington could.

With an eye toward reducing the farm's dependence on genetics, the Geigers have begun a compost business at Appleton Farms. When he's not arranging for foreign breeders or their agents to visit the farm and look at livestock and a business prospectus, James Geiger the compost-maker arranges to deliver a truckload of compost at fifty-two dollars per cubic yard to gardeners in Ipswich and surrounding towns.

It's got all the signs of being a very promising business. It's grown from zero to $25,000 a year in four years. It's really in step with the times in several ways, from the point of view that there's a need for organic materials on home gardens, and also from the production point of view. There's a need and an appreciation for recycling. There's always been a need for both of those things, but there's an appreciation for it now.

In direct contrast to the international economics of embryo transfer, the Appleton Farms compost business is decidedly local. The compost is made from the farm's own cow manure, plus horse manure trucked in from local stables, crab shells from a nearby seafood-processing plant, and seaweed retrieved after storms on Cape Ann's West Beach. "All of these people have a disposal problem," Geiger points out. "For instance, the crab-shell people would have to pay $60 to $80 a ton to have someone take it to a landfill site and bury it in the ground, which, needless to say, doesn't do much for the earth's water system. The same thing would happen with the seaweed. The horse manure they'd probably just be inclined to dispose of inappropriately."

A third source of revenue at Appleton Farms comes from the look of the landscape itself. During the past few years, film, television, and advertising producers have arranged to use Appleton Farms for location shoots. In summer 1989, a film crew

used part of the Great Pasture to re-create Civil War scenes. Geiger sees it as "absolutely the easiest money that comes in by farm standards. We have to essentially shut down for a day and help manage a group of people, a lot of whom have never been on a farm before. But it's usually quite interesting."

If you took a survey in Massachusetts, if you listen carefully to what people say, why they want to help save farms, I've been convinced that it's really from a landscape point of view. I think that the real benefits are other than that. I think they have more to do with our ecology, not to mention food production. But I think that the primary reason that people want to save family farms is for the landscape. So you begin to realize that you've got something there to sell here, too, perhaps.

The look of Appleton Farms also means something to James Geiger personally. He is spiritually invigorated as he moves from the barns to the pasture to the woods. A 230-acre woodland, already transferred to the Trustees of Reservations, contains the French-inspired "Grass Rides," intended solely for horses with riders. At places they lead to wooden-rail Kentucky gates, which riders can open and reclose from horseback. Within this loveliness one comes suddenly upon stone statuary quite uncharacteristic of the Ipswich woods. They are four massive stone pinnacles transported here when the Gore Hall library was demolished at Harvard College. Geiger has come to like these monuments, too. One was placed in memory of Francis Appleton, another for his son, the Colonel.

There is one place here where you come to a round point and the trails go off from the center of a wheel. In the center of the round point is one of these pinnacles with a couple of poems on it. Another is

hidden and ivy-covered in the woods at the end of a pine lane. Another is on top of a hill on a maple lane. At first I thought they didn't fit very well, but I've gotten to like them a lot. The other place I've seen things like this is in China, where there might be a field and peasants farming, and all of a sudden there's a stone elephant.

Most farmers, whether they admit it or not, do it for the landscape. I try not to talk about it, because most people aren't lucky enough to have that landscape at their doorstep, but I appreciate it, and I think it's just part of the privilege that goes with some of the liabilities of farming.

Removed as it is from the traffic of Ipswich, the open spaces of the farm attract a variety of strays and vagrants and fun-seekers. People leave cats, Mrs. Appleton observes, who reduce the mouse population, thereby depriving owls of food, she says. She keeps plenty of dogs around her, "to keep me informed of what's going on," especially out along the railroad.

There was a time about fifteen years ago when there were the most unsavory characters going up and down this railroad, and they shot out all our padlocks on the gates. I've gone out and seen a man fully armed. I called the police, and they said, "Leave him alone because we haven't got a posse, and it's no good. We probably know who he is, but just keep away." I said, "You just get a posse and I'll follow out where he goes." They got him. We had lots of that sort of thing in the past.

And these horrible motorcycles. I got attacked down here one time. I went to look for my cat, which had got to the other side, and I went on the track. Suddenly, these kids on motorcycles—well, they weren't kids. They were good-sized. They weren't so kiddish, either. They gave me a very nasty harassment, and I was having a bad time. They were spinning around and pretending they would come and mow me

down. I was trying to get to the back. Luckily, two people who work here just arrived down there, and they sped off. But it makes me realize you've got to be careful.

At age seventy-seven, Joan Appleton is satisfied that the farm will remain a beautiful place as long as she can help it. She traverses the grounds on a Yamaha golf cart, her legs telling her that they have suffered too many horse-riding accidents. But she still loves to ride horseback and exercise her dogs in the predawn light, "because then it's absolutely peaceful." The beauty of the farm—the life of it, really—sustains her.

There was a tremendous determination here and a great love and tradition for the place. All the Appletons felt it was worthwhile. I think that nearly everybody who comes on the farm says, "This is a very peaceful spot," and it raises their spirits right then and there. Somehow, that makes you feel it's a worthwhile thing. I grant you there are moments when you just wonder what in the dickens you're doing.

But you feel that it wasn't easy sledding for any of those ancestors, one way or another. So you just get the bit in your teeth and feel you must try to go on somehow. I think it's worth a tremendous try, and I'm very blessed in having James and Caroline, who feel the same way.

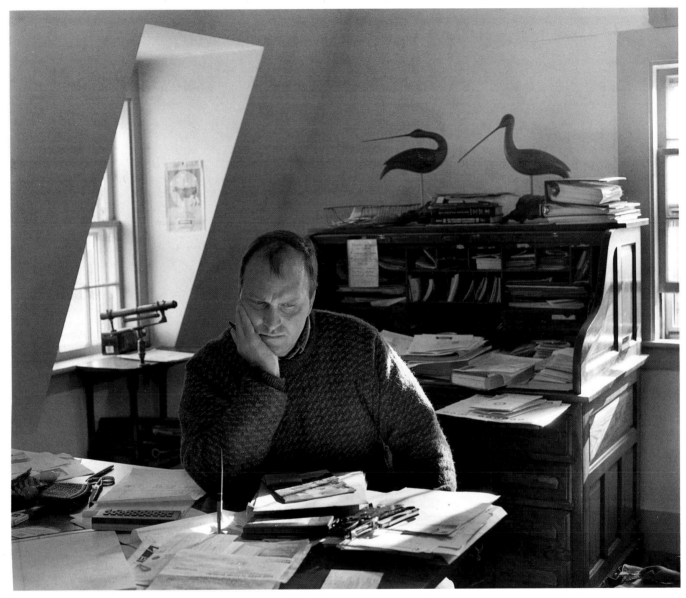

Whether you think about it or not, you're trying to create something you feel comfortable with. —JAMES GEIGER

I think it's worth a tremendous try, and I'm very blessed in having James and Caroline, who feel the same way. —JOAN APPLETON

I think the only way that I can see that you can really study a farm is to work on it and to see what the problems are. — JAMES GEIGER

I don't mind doing chores early in the morning, except when it's really cold. — MATTHEW GEIGER

This is a great place for our children to grow up. — JAMES GEIGER

Cassandra Geiger on her birthday, October 1989

My hunch is that the local product [compost] will be our primary business as time goes on. — JAMES GEIGER

The business is fueled primarily by the foreign market. Perhaps 50 percent of our animals are sold in the States and 50 percent internationally.
—JAMES GEIGER

James Geiger has begun raising Norwegian Fjord horses at Appleton Farms.

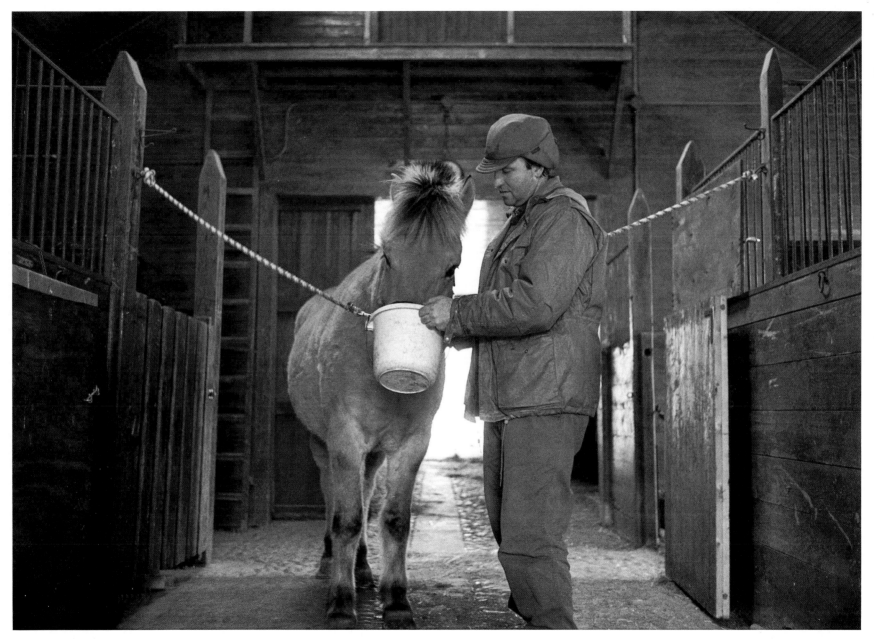

I've never been the kind of farmer that could milk cows twice a day for seven days a week. I've done it, but I can't live with myself when I'm doing it.
— JAMES GEIGER

24

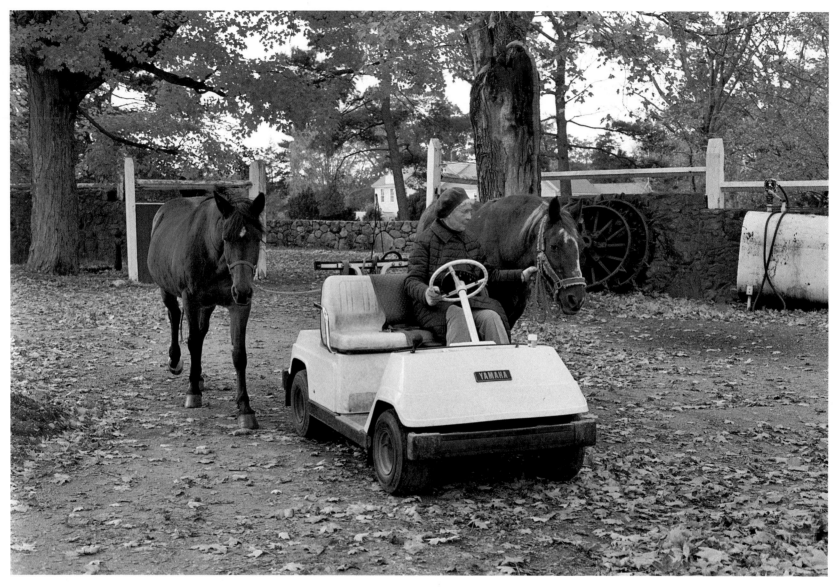

I always have liked to feed my horses early, so that when I want to get off at 7:30 and ride, they've got their meal inside them and are fresh and ready to go. — JOAN APPLETON

I have been quite firm about trying to keep [the land] for the wildlife and for those that live on it.
—JOAN APPLETON

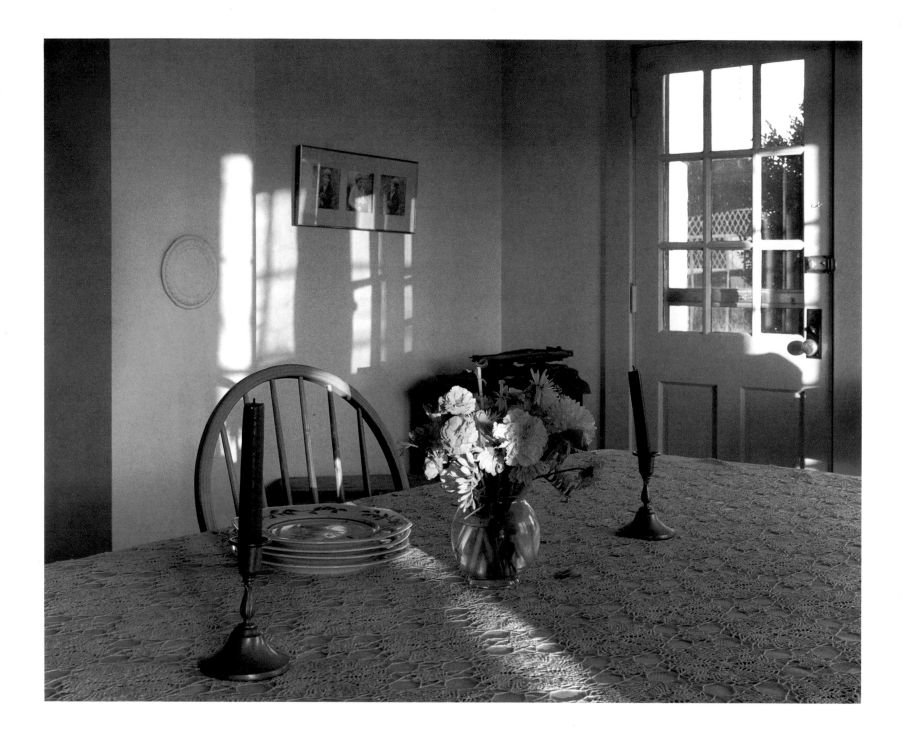

I think everybody would prefer the fall here, because there are no bugs then and the stock is much happier.
— JOAN APPLETON

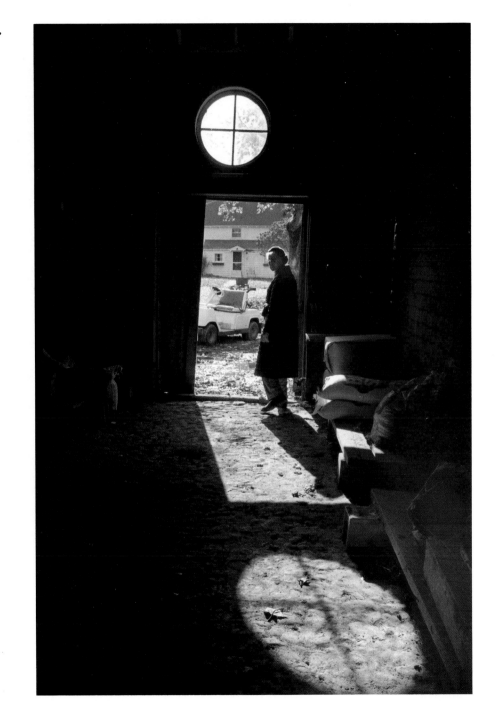

OPPOSITE PAGE: *The Geiger family table.*

I have felt for the past four years that I have been fighting the world, trying to hang onto this place up here and trying to make it work.
— RICHARD CHASE

Arrowhead Farm

NEWBURYPORT
Founded in 1683

When Arrowhead Farm in Newburyport turned 300 years old in 1983, Richard Chase, at thirty-two years old, had the place clicking. He was making money, growing food and flowers on fifty-three acres in Newburyport, and selling it all at the family's busy roadside stand on Route 1A in the next town south, Newbury.

By that time, Newburyport already had become a classy North Shore suburb on the Merrimack River waterfront. Richard Chase, born and raised here, grew up thinking he would run the family farm on the north end of town forever, just as eight generations of his ancestors had done. He thinks now he should have suspected something when as a boy he trudged along pulling a little wagonload of sweet corn to sell at the "Sandy Acres" housing development going up near the farm. But until he encountered the new neighborhoods of the 1980s, Richard Chase had been an unassuming character.

The main farm in Newburyport is the Moulton place on Ferry

Road, where Richard and his sister, Polly, and their mother, Charlotte, and her forebears had grown up. Ferry Road was once a major thoroughfare running to the Amesbury ferry at the Merrimack River. George Washington and his entourage passed along it on their way to the ferry in 1789, and a builder working on a family homestead reported his sighting of the procession by writing "Mr. Washington is here" on a rafter discovered some 130 years later. But once Timothy Palmer built the bridge to Salisbury in 1793, Ferry Road became a dead end.

These days, attracting customers to the farmstand Dick Chase built recently on the place is no easy matter. One way is to offer hayrides in the fall. Families show up on weekends and groups of schoolchildren on weekdays to be hauled on a wagon load of hay bales. A tractor pulls them through the farm and into the woods and grassy, open land of the adjacent Maudsloy State Park, all of which had once been part of Arrowhead Farm.

Squinting through his thick spectacles, arms crossed at his chest, Dick Chase watched a haywagon load of twenty people rumble down the Arrowhead woods road on an October afternoon in 1989. He talks like a real Massachusetts farmer, dropping the "r" in "farm" and adding one to the end of "idea," telling what he knows about crops, and how much farming means to him, mixing as much cheerfulness as he can into an otherwise weary tale.

Hayrides take up a lot of time. But they also bring in a lot of people. We bring in probably 500 people for hayrides on a weekend day. They don't necessarily do a lot of purchasing. But it acquaints them with us, where we are, what we have. So it's constantly building a retail base.

In a way I have a little problem with it. It's turning farming into a fair, or something, like a carnival. I have a little bit of a problem with that. But by the same token, it's somewhat educational, especially for the kids. Two years ago, when we built our temporary stand down here, we built a little henhouse beside it. We have 100 hens probably, and the kids have a good time with it. And I fully expected that probably nine of ten kids who showed up would not have seen a hen or gathered eggs. So we have them go into the henhouse and gather eggs. What really surprised me was the parents. Nine out of ten parents *had never seen a hen. I said, "Gee, I'm a generation behind here."*

Most people have been so far removed from farming for so long now. They never get off a pavement, basically. There is such a lack of understanding of what goes on in producing their food. It is good that we can get them over here. We have a captive audience for twenty minutes or so, and they can ask questions, they can watch what's going on. It's educational, there's no question about it. It's also a forum for environmental issues, open-space issues. So that sort of mitigates the carnival aspect of it.

But I'll bet you that one of every ten people on that haywagon would sue me if they didn't like the smell of my hen manure. That's just the way it is. They like coming out and looking at the farm, but they don't want it near them.

The farm's lore, recorded in account books, inventories, registers, letters, diaries, and other sources, is told fully and affectionately in a 1982 book, *Arrowhead Farm through the Centuries and Seasons,* by Charlotte Moulton Chase and her children, Pauline Chase Harrell and Richard Chase.

William Moulton began this farm with four acres and ended up in the 1730s with sixty acres, nine children, and several small industrial operations along the river. Moultons later bought, sold,

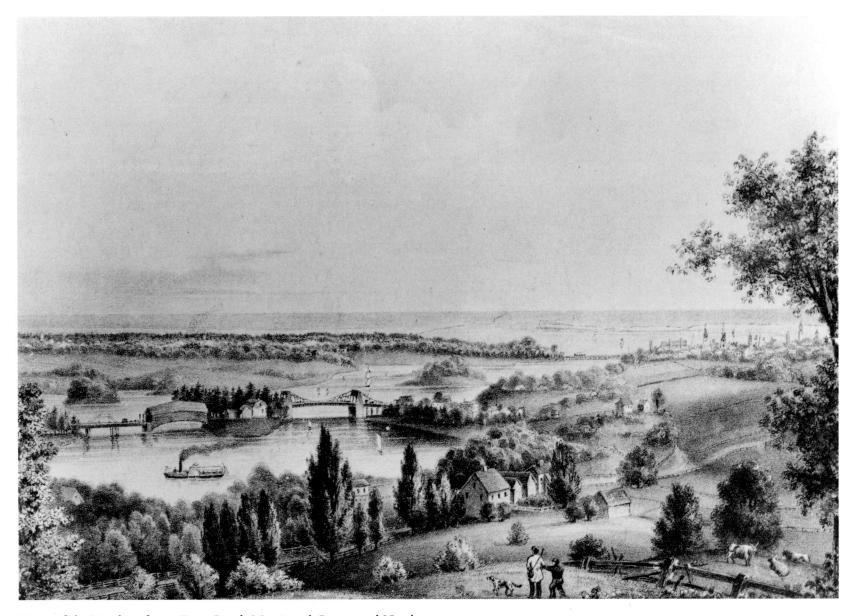

View of the Moulton farm, Ferry Road, Merrimack River, and Newbury

and swapped property with the neighboring Bartletts, Merrills, and Curriers. At one point the family had 500 acres. Through the generations the farm bobbed with the currents of Newburyport's fortunes. Today there are three eighteenth-century Moulton family houses which remain on the property. They have sheltered Moultons who stayed on the farm and engaged in all kinds of occupations. There were silversmiths, innkeepers, shoemakers, and shipbuilders, as well as farmers. The farmland supplied the families on it with all their food until trade with the West Indies and elsewhere overseas supplemented their fare with sugar, tea, and spices brought into the nearby port. The families kept animals for milk, meat, eggs, and wool. They grew vegetables and berries, firewood and lumber. They made garments and shoes. They provided not only for themselves, but for the growing port-city population of shipbuilders, tradesmen, and merchants. The latter 1800s brought summer visitors from the city to the countryside and beaches of the North Shore, some of whom boarded with the Moultons. In the 1860s, William Moulton wrote in his diary about carrying visitors by horse and carriage to Plum Island for summer picnics.

By the end of the nineteenth century, perhaps two dozen family members inhabited the home place. It was not the best of times. The region had turned to a factory economy, which was not as kind to farms as the foreign trade had been. North Shore towns were becoming a lure for those who could build big houses, some as summer residences. At Arrowhead, family illness caused hard times, too. To help make ends meet, John Currier Moulton sold 100 acres of the farm to financier Edward "Lord" Moseley, who had been buying most of the neighboring farms and was one of several men who built massive country estates in the area. And in 1897, the town of Newburyport took by eminent domain the Moulton farm's riverside land to use for a public water supply. It was not a friendly exchange. The family lost the springs for its own water supply, as well as good pasture and cropland.

John Currier's son, Charlie Moulton, grew up on the farm during these hard times at the turn of the century. Family history tells that Charlie was especially fond of the girl up the road, Sarah Lydia Moulton, the third daughter of his distant cousin, Joseph Bartlett Moulton. The Joseph Moulton part of the farm may have been in better shape, too, with a growing dairy herd and a vegetable and wood business. But Sarah's mother, they say, preferred that Charlie marry her youngest daughter, Rebecca, rather than Sarah. Nevertheless, a courtship between Sarah and Charlie ensued, complete with signaling by window shade across the family gardens, and in 1908 they were married. The joining of the two families boded well for Arrowhead Farm. Charlie expanded the farm's market, hauling goods into town by horse and wagon, including milk, eggs, apples, peaches, plums, berries, corn, and peas. His sisters, Ida and Lizzie, lived with them and shared in the cooking, laundry, sewing, and gardening. Sarah and Charlie had two daughters, Elizabeth in 1910 and Charlotte in 1914.

Arrowhead Farm through the Centuries and Seasons contains photographs, taken by his sister Lizzie, of the farm as it existed under Charlie Moulton. As the family says in the book

Lizzie's pictures show a life of hard work, cooperative effort and simple pleasures—evenings spent reading, playing checkers, making music; summer picnics at the beach; and much visiting back and forth with Charlie's sister Hannah and her family in Hampton Falls. Outside, they show Charlie and others working in suit vest and trousers—a nineteenth-century mode of work dress he carried on to the end of his life, relegating his older suits to work status, and pulling on his "over-hauls" over them when he worked in the barn.

When it comes to making a major decision of whether to continue the operation here or move it, then you have all these generations of ties that enter into it. It's very hard to make an objective decision. — RICHARD CHASE

Charlotte Moulton

Inside, they show a comfortable mélange of factory-made Victorian furniture and older pieces set against the light, airy, uncurtained windows popularized by the Beecher sisters' homemaking books, and complemented by a luxurious array of house plants.

The homestead soon blossomed with well-mowed grounds, shade trees, gardens, and flowering plants. Then came the freshness of electricity, automobiles, and croquet on the lawn in summer evenings.

The generation after Charlie—Richard Chase's mother, Charlotte, and his aunt, Elizabeth—grew up here and tended their flowers and vegetables while helping with the livestock and harvesting when they wanted to. They weathered the Great Depression without undue hardship, mainly because the family was accustomed to providing for itself. The food and fuel, the clothing and entertainment were made right there on the farm. In 1937 Charlotte married Glendon Woods Chase of Newbury. Glen had graduated from the Essex County Agricultural College and worked with his father at the family dairy farm in Newbury. As a boy he would come to Arrowhead to buy sweet peas which Charlotte tended in the family garden. The newlyweds moved out of town for only a year before returning to farm in 1938. Together, Charlotte and Glen grew fruits and vegetables at the Moulton place and established a greenhouse operation called Sunnyslope Greenhouses on the Chase farm in Newbury, where they also built a retail farmstand alongside Route 1A. The horticultural business fared very well. Charlotte became known for her floral designs, and Glen for his ability to grow a variety of flowers and other plants.

In the 1950s the Chases concentrated on their greenhouses in Newbury. Agriculture waned at the Arrowhead property in Newburyport. Charlotte's aunt Rebecca sold twenty acres of river-

Charlotte and her sister, Elizabeth, tended the gardens and helped with farm chores. Charlotte later earned a reputation for producing beautiful floral designs.

Richard Chase, July 1954

slope land there, figuring it would not be farmed anymore. As though sensing another opportunity, the city of Newburyport in 1953 again took Arrowhead land to expand the city's water supply. And the Commonwealth of Massachusetts took other land for the new Interstate Highway 95. Nevertheless, Glen and Charlotte pursued their interest in diverse horticulture, and at the Newburyport homestead their two children took on a few pigs, a steer or two, ducks, geese, and chickens. Young Polly grew flowers and tended the garden. By age thirteen, her brother Richard was already the farmer at Arrowhead, producing sweet corn on an acre-and-a-half. By the time he was twenty-one in 1972, Dick was

growing thirty acres of corn, twenty acres of squash and melons, and twenty acres of small vegetables, all of which he sold either at the stand in Newbury or to Boston wholesalers. He raised some livestock—turkeys, pigs, and heifers—through the 1970s before turning exclusively to the burgeoning retail market of fully suburbanized Newbury and Newburyport.

*　　*　　*

When his father died in 1981, Dick already was growing as wide a variety of fruits and vegetables as he could handle on Arrowhead's Newburyport acreage, which is mostly sloping land and boney soil, "about the worst soil in the world for a farm." He was selling it all at the family's Newbury stand to passers-by on Route 1A, and everything was working very well.

True to the tradition of Arrowhead Farm, Dick Chase enthusiastically experimented with new varieties of crops, new ways to grow things and to sell them. Arrowhead went into Christmas trees early, planting some 2,000 per year on slopes that really didn't need much water. Dick talks with pride about his extensive work in cultivating fruits and how he put in new fruit trees every spring to make a 5,000-tree orchard.

We have a real wide variety of fruit trees actually. I figure the more variety you have, the more people you attract. We have a lot of oddball things you don't see growing much anymore. I've got a small apricot orchard. We picked about 3,000 pounds this July. And they sold out very quickly. Retailed the whole thing. We've got sour cherries, sweet cherries, nectarines, plums, apples, pears, peaches, some white peaches. This past spring I set out about an acre of a hodge-podge assortment of fruit. I did several varieties of grapes, red cur-

rants, black currants, teaberries, boysenberries, elderberries, blueberries, quince, rhubarb.

The trees are mostly dwarf fruit trees. Dick's plan was to open the orchard to the public, to open a pick-your-own fruit grove.

So we want trees that are going to mature at about seven feet that can be picked pretty much from the ground. The big thing in pick-your-own fruit is the difference in the cost of insurance; picking from the ground versus picking from a two-step ladder is considerable. So we are trying to stay with very dwarf trees. That's why the high numbers. The older two orchards on the farm were planted with standard-sized trees, and they're spaced thirty-by-thirty feet, and that figures out to something like forty to fifty trees per acre. The dwarfs we're planting we're doing four-by-twelve feet, almost 1,000 trees per acre.

And the idea of selling pick-your-own fruit was young when Dick Chase first opened the strawberry beds in the mid-1970s.

We were growing strawberries for chain stores. We were selling to Stop & Shop, Finast, and sending some into Boston Market. Some days we had fifty or sixty kids, college students, whatever you could find for help, picking strawberries. We didn't have too much trouble getting a crew like that together. It got harder and harder. About fifteen years ago we got out of that completely, because we just could not find good help that you could live with. The straw that broke the camel's back was in 1973. We had sent 1,300 quarts of strawberries into the Finast warehouse in Somerville. I got a call from their buyer after lunch: "What in the hell are you trying to do?" Well, we were paying piecework. We were probably paying twenty or twenty-five cents a quart of strawberries. Somebody had come up with the idea of taking the salt-hay mulch from between the rows and stuffing the bottom of the boxes. Then they figured out that the weight wasn't the

Dick Chase and his first ear of corn

37

same, so they took a couple of rocks, put them on top of the hay, then frosted it with strawberries. So we packed them up, twelve to a crate, and sent them into the warehouse. The warehouse cellophaned them, sent them out to the stores, somebody bought them, took them home, took the cello off, and there it was. So, somebody did it. They did a whole mess. There were two or three dozen quarts done that way. So, OK. We had about fifty or fifty-five kids picking strawberries the day before. Who did it? So that was the end of it. That was it. The very next year we started pick-your-own. And it worked.

That was really back in the beginning of pick-your-own. We had some reservations about it. People said, "They're going to trample all over your beds, then leave." Well they're not going to trample your beds any more than high-school kids picking them. They said, "The people will eat them all." Well, the kids you hire to pick them throw them at each other. So what's the difference?

In mid– and late April, Arrowhead would remove the cool crops—peas, beets, lettuce—from the greenhouses and plant them outdoors. The week before Mother's Day, the familiar Newbury roadside stand would open. They would sell the bedding plants cultivated in the greenhouses. Meanwhile, summer crops would be planted at the Newburyport fields. Strawberries came in June. They tended fields in July to get ready for the corn and tomatoes, then the beets, carrots, beans, and squash. Upholding the Arrowhead reputation for flowers, established by his mother, Dick began raising flowers. People come out to the farm and pick flowers for their own bouquets.

People go in, make their own bouquets for a buck-and-a-half, and they love it. They love it. Give them a pair of shears and pick a dozen of anything you want. And I try to keep a big variety of flowers out there. People go around and pick one of this and one of that. They come out and get flowers for their own weddings. They might cut 100-dozen on a Friday night for a Saturday wedding.

After two major land- and water-takings by the city of Newburyport in the past 100 years, Arrowhead had lost most of the natural water supply which irrigated these fields for its first two centuries. The diverse crop production Dick Chase wanted to handle required predictable irrigation. He set up what was, at the time, the best watering system for his fields.

We put in overhead irrigation about fifteen years ago and it improved quality and production, but it was also assurance. Prior to that we could lose our whole sweet corn crop because we might not have enough water. We put that in and we really thought we were onto something. You could just move a pipe around a field and there would be water right there. After doing that for a few years, you discover that it's really expensive moving the pipe around, and you get up at eleven and move pipe, then you get up again at three in the morning and move pipe.

So the past two years, we've been putting in underground drip all over the farm. It's a system that came out of Israel about ten years ago. It's all plastic pipe, and each field is valved off separately. What before took six or eight man-hours to irrigate an acre takes me all of a minute with this system. Where I would use 800,000 gallons on a certain crop before, I probably use 250,000 now. It's less than a third.

Basically the tubes just go along the crop about two inches underground, and every thirty inches there's an emitter—a pressure-regulated dripper—which puts the same amount of water onto each plant, so you're only wetting the root area, and you're not wetting the walkways and drives between the root areas. And in the summer, when the sun is hot and the wind is blowing, the overhead sprinkler water is broken up when the wind blows it, so only half of what

comes from the sprinkler actually goes into the ground. The rest is lost, gets dehydrated when it hits the soil. With the drips you don't lose any water. I've been doing that with an ASCS [Agricultural Stabilization and Conservation Service] grant which pays fifty percent of the cost of putting it in. This year we spent $38,000 putting in underground drip. Almost everything is done now. We have one more section to go. We do everything but the Christmas trees. They seem to get by without water.

By 1985 the Newbury stand grossed $200,000 in annual sales. Dick decided to expand the Newbury operation. He had in mind a natural expansion of the roadside stand and greenhouse operations that had become a landmark between the First Church and the Green in Newbury. He believed in the need for local agriculture, especially in the growing Boston suburbs. He was encouraged, too. The Massachusetts Department of Food and Agriculture had begun its "Massachusetts Grown and Fresher" campaign to enhance the interest in locally grown and marketed produce. By and large, people who had moved to the suburbs revered the local farm as a place which preserved the heritage of New England towns. They enjoyed stopping in at the farmstand for strawberries in spring and fresh sweet corn and tomatoes in summer. Dick Chase wanted to make a living at it, just as his father and grandfathers had. Next to the farmstand he wanted to have greenhouses to nurture the seedlings, a barn to store the produce, and a kitchen to make jams and jellies. He figured it would be a naturally acceptable business in the center of Newbury. Here is how he tells it:

The farm in Newbury was my father's farm. We don't know exactly how long it was in that family. History on my father's side of the family is very sketchy. It was in that family in the 1860s. We can pick

it up there. Prior to that we just don't have any information.

It was a farm until the spring of 1987. It was the retail market for this farm. We had the farmstand down there, we had five greenhouses down there where we grew bedding plants, we had what had been a dairy barn with a milk processor converted to a processing plant for vegetables, with packing facilities, refrigeration, cider press, that sort of thing. The stand sold the production of the greenhouses down there and almost all the production from the farm up here, plus a lot of produce we bought. We bought all our apples. And we bought anything we'd need during the year. It was right on Route 1A. It was really easy to do business there; you just opened the door and people came right in. You didn't have to do any advertising, you didn't need gimmicks to get people to come out.

In 1985, I decided we really needed to modernize our facilities down there. So I put some plans together, to build a new roadside stand, take the dairy barn and put in a new cider press, kitchen facilities, a new cooler that we could drive into with a forklift instead of handling everything by hand. We were going to take down two of the greenhouses that were in poor repair and put up two new ones. And we were going to add four spaces to the parking lot, go from twelve cars to sixteen cars.

We also had the farmhouse down there which we had been renting, which basically hadn't been touched since the 1930s. It was in pretty poor shape. So we figured we would fix that up to rent. We figured on financing it by selling a couple of house lots off the farm area there. That would have left us with five acres, with the greenhouses, the processing and some pick-your-own down there, mostly cut flowers. And we were going to sell two one-acre house lots to help pay for rehabbing everything.

We had to have a variance from the Zoning Board of Appeals to have the two house lots, because we were eight feet and twelve feet

short of frontage, respectively. A minuscule amount, but we needed the variance. So we went to the ZBA, and we put the plan before them — which was a mistake, but that is what happens when you try and do something yourself. I didn't figure I needed my lawyer to do it. I knew everyone on the ZBA, knew everyone in town. So we went down and presented them with what we wanted to do. However, I went further than simply telling them I needed the reduced size to sell the lots. I told them why we were planning to sell the two lots — we would take the tin stand out, put up a new one the same size but more modern.

Well, within a week, we had nine appeals filed by neighbors. I guess I had my head in the sand, but I said, "Who are these people?" Of the nine, seven of them had not lived in Newbury in 1980. So they were all newcomers. They had bought houses and built houses next to us, which to my way of thinking they paid too much for, all those old farmhouses in the neighborhood down there. They brought prices in the $400,000s there. That's crazy. And they were very suspect at what we were doing. They figured "new stand" meant "convenience store." That's basically what they had in the back of their mind. And they came out with all these allegations and suspicions that we were going to sell milk, we were going to sell cigarettes, we were going to sell dirty magazines. They had a petition going around that called for a 100-car parking lot, and the permit clearly spelled out sixteen spaces. That was just nuts. Absolutely nuts. They had no legal ground to appeal the farmstand. But they did have a legitimate appeal against the two house lots, and that's what they went after, basically, knowing that was going to finance the rehab.

I figured, what the hell, I'm not going to let these idiots push me around. We're just going to go ahead with this thing and it will wash out. Food and Ag got involved. They sent their legal people down, and they assured me the state statutes allowed me to do this. The

neighborhood formed this neighborhood association — Upper Green Neighborhood Association. It included two families with both mom and pop lawyers connected to state government. They were able to go through a newspaper editor in Worcester who was very close to Governor Dukakis. And they were able to pull the rug out from under the legal services from Food and Ag, which Food and Ag normally provides in cases like this. The whole thing was very political.

But we persevered. I borrowed the money to rehab the house, tear the greenhouses down, and we started construction of the new stand. The town gave us the permit for the stand because there was no variance required. The first thing I knew, we got a cease-and-desist order from Superior Court to stop building the stand.

Finally, as it washed out three years later, we got a court order that ordered us to remove what we had started to build of the new facilities, which we did. By that time I had already spent about $100,000 on the project. We had spent nearly $30,000 in legal costs. We were paying interest on that. We had no retail facilities, mind you. The old store was torn down, the new one is not done. We were selling out of a truck down there.

Then I finally said, the hell with it, we can put up a stand at the farm here [in Newburyport]. And we did. We had enough response to figure, if we do it right, we'll probably get enough people up here. So I figured we'll sell the property down there.

We put the [Newbury] place on the market and ended up selling it to the Congregational church, which is one of our abutters. And they were very eager to buy it. They had been looking for land for a while for a parsonage and a youth and recreational center. They figured it was ideal, property right next to the church. So they purchase the property, and they had figured on doing exactly what I had figured on doing. They were going to sell four house lots in order to finance what

they wanted to do. I figured it was a real safe deal. The nucleus of the community is the church down there. Everybody in town government was in church government, a typical little Congregational church. So being a nice guy and somewhat desperate, I took back paper for eighty percent of the purchase price. I took back paper for $550,000 for a year.

Within two weeks of the closing, the neighborhood association had appealed everything the church planned to do and filed suit against them, because of the youth center. They didn't want any of those people in the neighborhood. And it just hamstrung the whole thing.

So here I am three years later: the church hasn't been able to make a move, because that case is still in court; the suits against my wife and me for building a roadside stand are still in court, because the neighbors won't let them go; they have monetary damages out on it now, trying to recover money they had spent in court. So it's a hell of a mess.

I guess what's going to happen is we will end up selling $550,000 worth of paper for about $300,000. Just trying to bail out.

After I sold the property in 1987, I had to borrow money to pay the capital gains tax, which was horrendous because the property had been in the family since way back, no basis. So I think our capital gains net was about $140,000. I was already in the hole for $130,000. So it was almost $300,000 that I owed. So I'm paying almost $3,000 a month in interest, and I don't have a store to sell anything out of. It's a calamity of errors, poor judgment, inexperience, whatever you want to call it. One built on the next as it went along. I'll tell you, it kind of shakes your confidence.

Newbury is becoming a very elitist town. They suffer from the burn-the-bridge syndrome down there: "I've got my house, now we don't need any more here." Over the past decade, Newbury has gone from what was a very conservative, blue-collar rural community to a very elitist, upscale, white-collar community. It's done a real 180 in

just ten years. It's really amazing. What the neighborhood group wants to do down there eventually is set up a historic district. Most of the homes in the area are old. A lot of them date back to when the town was settled in the 1630s and 1640s.

I am just so burned out with the town down there that I wouldn't operate a farm if they gave me the place. I would be very happy rebuilding a retail operation up here, if I had some money to do it with. I started building a new house about six months before this whole mess went down. So I had a mortgage there. So with the house mortgage, the money we borrowed for the taxes, the money we borrowed to rebuild the property down there, I have almost $500,000 in outstanding notes. We're paying about $5,000 a month in interest and haven't been able to move in two years. It's just absolutely drained us of every liquid asset the place had. The past six months we've just really hit bottom. There's been no operating money left. Everything that comes in goes to pay interest. Machines break down, we set them aside, because there's no money to repair them. We had to stop advertising because the newspaper bill hadn't been paid. It has just snowballed downhill the past six months.

Two years ago when it became evident that we weren't in a very good position financially, we were looking around for something to do to improve the cash flow and reduce the debt. I looked at taking the old [eighteenth-century] house in the middle of the farm here and maybe selling it, because there had been a lot of interest in that house from people wanting to buy it and restore it.

Well, we didn't want to sell a lot in the middle of the farm. So we decided we would cut a lot on the east end of the farm and offer that lot and the house as a package for someone to pick up the house and move it down there. So we got a realtor from Byfield who sells exclusively antique property on the North Shore and all Essex County. She came over and looked at it, and did some nosing around the market

and said, yes, it's a real feasible thing to do, you can probably realize $185,000 to $200,000 for that.

Well, we have very strict zoning up here in Newburyport calling for three acres per house lot and 300 feet of frontage. That zoning was put in before the state bought our property next door for a park. The city of Newburyport was afraid that a lot of those parcels of land would go into development, so they pushed three-acre zoning through very hurriedly to squash development over there until the state could get its act together and buy some of the property. That worked. It was a good move. However, after the state came in and bought the property, they did not redo the zoning. So we are left basically as one of two farms in the city with this ridiculous zoning.

We had 288 feet of frontage on the east end of the farm where we wanted this house lot. So we had the engineering done for moving the house, setting up the lot. We had to go to the Zoning Board of Appeals in Newburyport to get a variance to sell a lot twelve feet short of frontage. We told them why we needed it, to move the house down there and sell it so we could preserve the farmland and wouldn't take any more crop land than necessary. Bingo! Shot right down! "Absolutely not. Set a dangerous precedent. Blah, blah blah. No hardship." So we got that shot right down.

So we said OK, let's step up the activity in our gravel pit a little. We were really starting to get nervous about cash flow at this point. We got a couple of contracts for gravel. We had been selling gravel out of here for years, but small amounts. If we had a particularly tough year and couldn't pay the property tax we'd sell a couple thousand yards of sand or something to pay the tax bill.

We got a couple of good sales in, $10,000 or $12,000 each, started hauling, didn't think anything of it. I'm not crazy about selling gravel out of the place anyway. It makes a hole. I figured we'd grade it out and plant Christmas trees behind it, which we've been doing.

We'd been hauling about three days, I guess, and the police come up and they have an order from, who was it, the city council or somebody: "Shut the pit down. Illegal use in a zoned district." So we had to go through court with the city to determine yes, this was in continuous use from a date predating the adoption of zoning. That cost us a year and about $15,000. You know! We are trying to hang on to this open space up here, and not only will nobody do anything to help, they put roadblocks in the way every place they possibly can!

That's not all. The century-old battle between this farm family and the city of Newburyport over the municipal water supply continues.

As far as the municipal water supply area next to us, I think we have been screwed for the past thirty years, actually for the past 100 years. Twice the city of Newburyport has come up here, taken acreage from this farm, put in wells, and ruined our water supply. On the other side of Ferry Road, in the 1890s, they took by eminent domain the spring and the stream which the farm relied on, and left us high and dry. They did at the time agree to provide water to the farm at no charge in exchange for losing that watershed site.

In the 1950s, they needed more water. They took land on this side of the road, put in a deep gravel-packed well. They take 300,000 gallons a day out of there. They dried up both our irrigation ponds completely. Lowered the water table on the whole farm fourteen or fifteen feet. And ten years ago, when we put in a new irrigation system, they determined that they could no longer supply us with water, even though they had agreed to. And they have since started sending us water bills for $5,000 or $6,000 a year, which I have refused to pay and which is in court. They are still supplying us with water, but they are adding $5,000 or $6,000 to the bill each year. That is still in court.

Richard Chase is thinking about closing down Arrowhead for good. His sixteen-year-old son, Justin, most likely will not shepherd the farm into its tenth generation.

I have felt for the past four years that I have been fighting the world, trying to hang on to this place up here and trying to make it work. For twenty years I ran it. I enjoyed doing it, I made a living from it. I wasn't in court every other week.

I don't know anymore. I have considered other areas of the country where we might move the operation. I have not considered another career. I really like what I do. But I really am strongly considering other areas of the country to do it in.

Our son Justin has seen a lot of stress over the last couple of years, strung out with lawyers, not enough money for things. . . . If farming in Massachusetts is going to continue the way it has for the past decade, I would hope my son would not get into it here.

There is a whole lot of emotional baggage that goes with farming family land like this. The past couple of years all I've been able to do is moan about the business here. After a while you begin to feel, "Have I got the poor me's or what?" You start to feel you are out of line for feeling persecuted. There is that aspect of it.

When it comes to making a major decision of whether to continue the operation here or move it, then you have all these generations of ties that enters into it. It's very hard to make an objective decision. It becomes real hard.

I really like what I do. Growing and selling crops. I like it. I really love it. It's what I've always done and I really like it. And I like living on the farm here. I don't like some of the encroachment. I don't like the sound of the interstate highway. And I don't like some of the people that come on it. But they also come as a good market for what you grow. So it's kind of a mixed blessing.

But I'm really angry that Massachusetts as a government entity has screwed up agriculture so badly, because it really has. I feel they are really limiting my ability to do what I like to do. I get angry about that.

It is hard to sit here and say will we move, or will we try and dump some more money down the drain here, with all these emotional attachments. My wife has never had any sense of family history on her side of the family. She has been doing some genealogy the past few years, and she's managed to get back about four generations up into Cape Breton. She often laments that she doesn't have the family heritage I have. I tell her, "Boy, God has blessed you and you don't even know it." I feel like I am carrying a load that I don't want to carry.

The only way you can look at a situation like this is that the generations before have had the property in their time, had the land in their time, and they have done with it as they saw best. Some of them stayed here and farmed, some of them left, some of them bought farms elsewhere. Every generation had its problems. But they all had their window of time to make their decisions in. And that's what I have, and I can only do what I think is best to do.

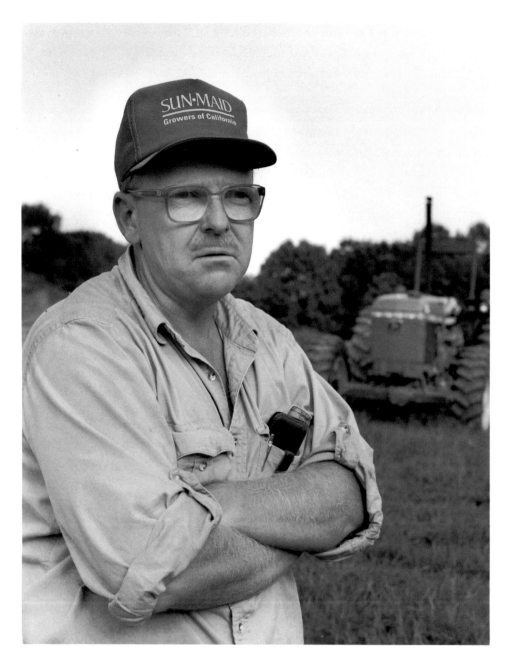

44

Most people have been so far removed from farming for so long now. . . . There is such a lack of understanding of what goes on in producing their food.
—RICHARD CHASE

I enjoy working for Dick Chase. He uses organic methods and is growing a variety of apples that haven't been grown in New England for a long time.
—MARY MISRAHI

We spend most of July doing field work, cultivating, spraying herbicides, top dressing, fertilizer, that type of thing.
— RICHARD CHASE

We bring in probably 500 people for hayrides on a weekend day. They don't necessarily do a lot of purchasing. But it acquaints them with us, where we are, what we have.

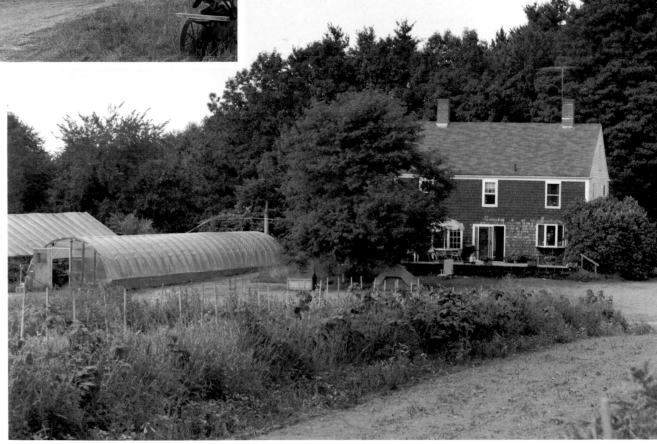

We're looking at taking this house we're moving out of and setting up maybe some employee housing here. Rents are so high in the area now, it's really hard to get people to work here.—RICHARD CHASE

48

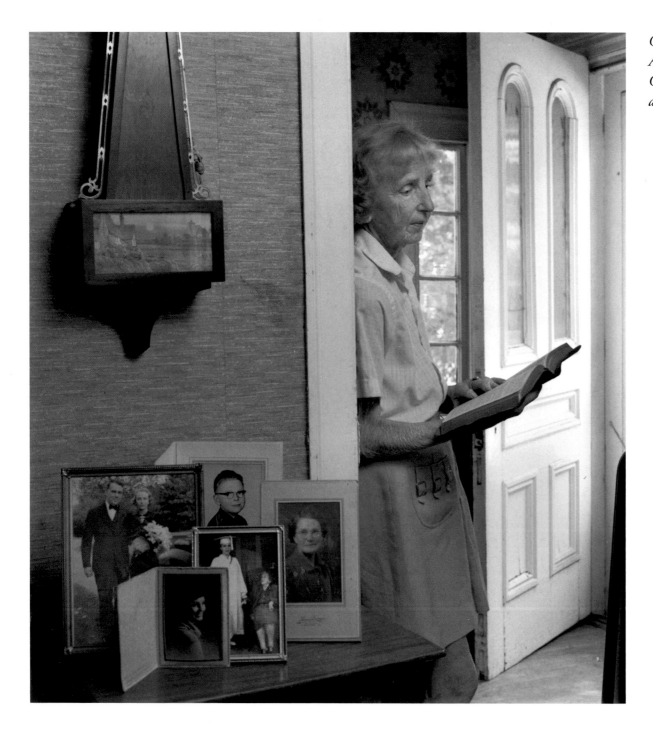

Charlotte Moulton grew up at Arrowhead. She and her husband, Glendon Chase, took over in 1938 and raised their family here.

I'm interested in the farm to a point. I like living on it, but I have no interest in farming it.— JUSTIN CHASE

If farming in Massachusetts is going to continue the way it has for the past decade, I would hope my son would not get into it here.—RICHARD CHASE

The greenhouse work has been going on here since the late 1930s. It was cut flowers originally. We switched over to bedding plants in the early 1970s. Now its completely bedding plants.—RICHARD CHASE

I'm looking at replicating one of the barns that is already on the property. It was built somewhere around 1800.—RICHARD CHASE

For many years the farm held three separate households of Moultons and Curriers.

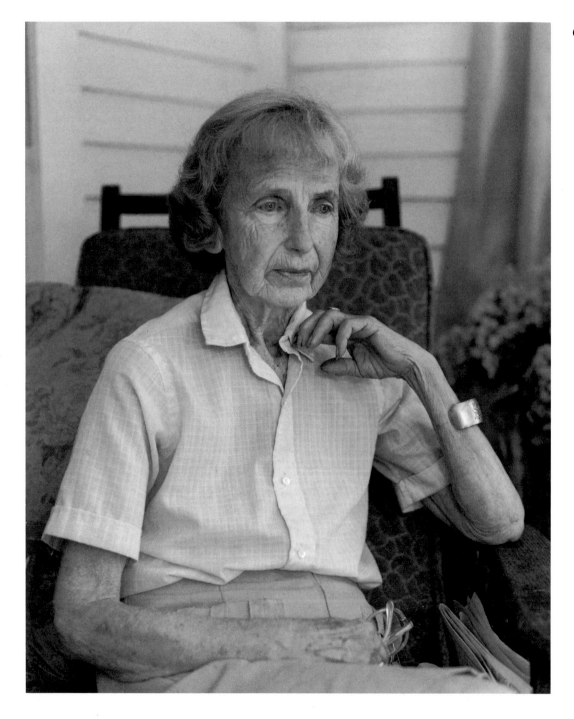

Charlotte Moulton Chase

Some of them stayed here and farmed, some of them left, some of them bought farms elsewhere. Every generation had its problems.
—RICHARD CHASE

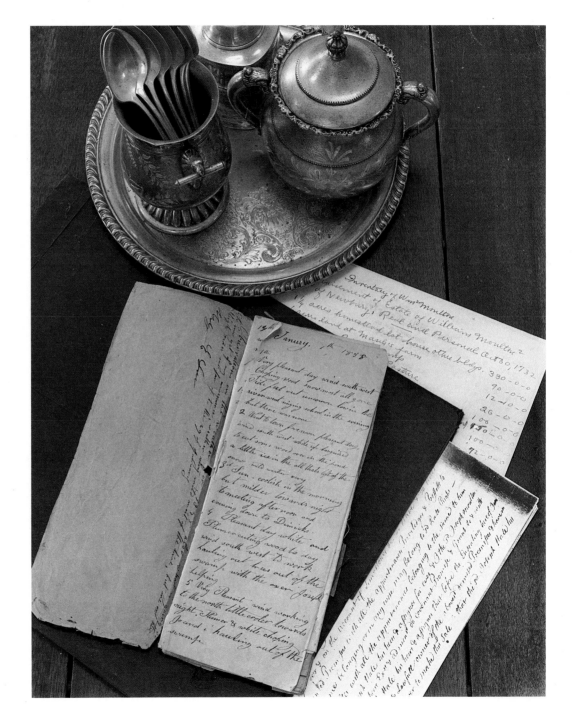

It's going to be more and more difficult, as time goes on, to save open space. —LAURIE BARKER LUNDQUIST

The Barker Farm

NORTH ANDOVER
Founded in 1643

In 1643, Richard Barker registered a purchase, and that record is considered to be the earliest one in the town of Andover, Massachusetts. It gives him the distinction of furnishing the earliest evidence of someone living there. He lived near Cochichawick Lake and had the second largest estate in town, some 310 acres.

Richard Barker was a leading figure in all town affairs for fifty years. Five of his six sons settled permanently in Andover. His second son, William, testified at a witch trial in 1692 that he had been "in the snare of the devil three years," trusting Satan to pay his debts.

The Barkers eventually established farms and residences along most of the big Cochichawick Lake.

The Barker family was one of the biggest in Andover in the eighteenth century. The achievements of family members are recorded in the annals of New England medicine, education,

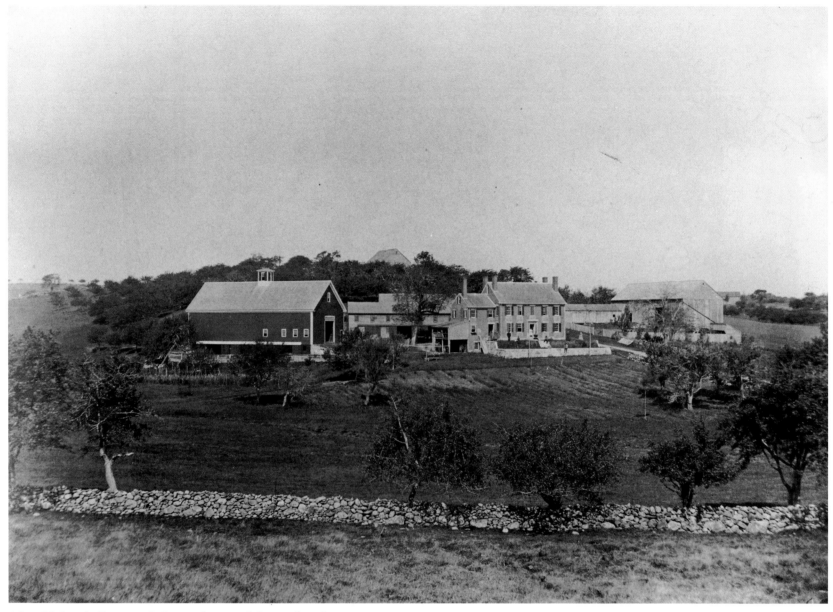

The old family farmstead is now the site of the Barker dairy.

business, religion, and government. Barkers also remained as large, influential farmers in North Andover.

Local history tells of the care and precision with which Barkers passed property to their children. One such record shows William Barker, the confessed witch, willing his second son, Stephen, the family house and farm (half in 1714 and the remainder once both parents were dead), as long as Stephen "Shall cearfully & faithfully manure & carry on my whole Liveing yearly" and pay his father "one half of all ye graine of Every Sort that Shall Be produced . . . from ye Lands yearly."

Carefully and faithfully carrying on the Barker farmstead, George R. Barker, Jr., who farms the place today, represents the ninth generation of Barkers at the farm. Sometimes, he says, he feels as though he already has been there for more than a lifetime.

For a few winter days in the 1940s, George Barker, Jr., cut ice on Cochichawick Lake. Other than that, he has worked only on the family farm. "I worked on the lake maybe a week," he says in a slow and modest monotone. And he grins to himself, "I think it was less than a week. I stayed there as long as they wanted me. I don't know whether it was an emergency situation or what. But I never did want to work for someone else."

He did work for his father, the senior George Barker. They milked cows and grew fruits and vegetables, cut hay and wood. In the 1930s, George Sr. made a name for himself by introducing yellow sweet corn to the region. He also established the farmstand on Osgood Street (Route 125) in North Andover. The stand, the lovely yellow corn, and the dairy are what sustain the Barker farm today.

My father and I worked together very well. I think maybe he was a little bit too easy on me. If I goofed up once in a while, he wouldn't

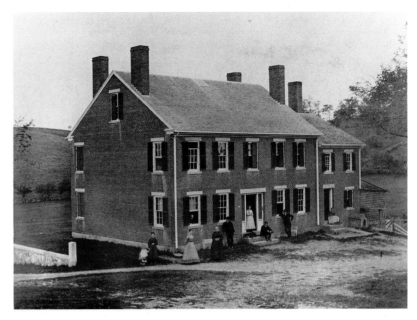

The Barker house on Bradford Street burned in the 1940s. Today, its foundation is used to store silage.

say anything. Maybe that's one of the reasons I wanted to stay. Pretty much, he would say, "Go do this." Or, "Help me with this. Then next time, you can do it."

An ethic of individualism is ingrained in the Barker family. Each person seems to have a birthright to follow his or her desires. Yet the liberty itself has not come free. Individuals of foregoing generations worked hard to attain a respectable position and business, in the community and beyond. But whatever a Barker accomplished was attributable somehow to his or her place in the family. Wherever one or another brother or sister would wander, there was usually some family explanation. George Barker, as one

who stayed on the farm, admits to being left to his own devices as a young man, but he also realized the unspoken and intangible affinity to his family.

His youth on the farm was within "a working family, you might say." A few farm workers would help at certain seasons, men from nearby Lawrence and from Andover. They arrived in the morning, some on the trolley which ran out front on Osgood Street, and they brought their own lunch. The Barkers themselves would have dinner as a family at midday in the main house. His mother, George remembers, was an all-star cook. "Best apple pie you ever had!" She made cakes and cookies and everything. She was especially adept with the abundance of fruit and vegetables grown on the farm. As the seasons and markets dictated, George's mother would pick strawberries and beans and other small vegetables. She graded apples and peaches. And she held forth in the roadside stand the family had erected in the 1930s. "She would not be working out in the fields or in the barn," her son says. George and his father were out there.

Year-round, I got up at 4:30 in the morning, went over and helped with chores, then came home and ate breakfast, went to school.

We had about twenty-five cows to milk. I'm very happy to say that we did not milk by hand. In 1932, just about the time I came along to help, my dad got milking machines, so that was good; although, of course, we did go around after to strip the cows, which I didn't do too much of. I guess I mostly put the machines on and took them off and fed out.

Seems to me I didn't do too much in the afternoon. I really don't quite remember. But, of course, in the summer I did, like planting strawberries and haying and pruning the apple trees and all that kind of good stuff.

In summer I worked mostly all day.

I did a lot of planting and cultivating. I guess my first job was leading the horse to cultivate with. Then we got a tractor, and I would pull three cultivators with my dad and two other people on behind, cultivating corn, mostly.

Haying was always a very busy time. Sometimes when sweet corn was in, we'd be working from 4:30 in the morning to 9:30 or 10:00 at night.

Hay and strawberries usually came in at the same time. Hopefully, we were done with the haying before sweet corn came in.

Working the way I did made you a pretty rugged kid, and you really didn't have to take much guff from anybody else. Even though it was long hours, I enjoyed the work because it was outside and because it was always different.

In those days, pretty much every job on the farm was hard.

My father had a lame leg. He got caught in a drag behind two horses and his leg was pretty well banged up. He couldn't do some of the things that he might have done, so he usually drove. I don't say he always drove, but he had the important job, like running the hay fork on a load of hay, you know, the fork that takes it up in the barn and runs it. At haying time, I would be the one to drive the truck. A couple of men would be upstairs stacking it away. So sometimes I got the easy jobs and sometimes I didn't.

There was a time when we worked with a pitchfork and a wagon and a hay loader. A few years there when help was hard to get, myself and maybe one other person did all the haying, which was a lot of haying in those days. We filled three barns. Now I fill just one. Even the first ten years of baled hay, we would fill two or three barns.

When he and his bride, Dorothea, were ready to take over in 1950, the farm was 308 years old. George had made sure the farm had a tractor, a Farmall H. They expanded both the farmstand

and their family. They moved from the bungalow down the road into the main house. The elder Barkers moved into the bungalow.

George and Dottie now have four daughters in their thirties — Diane, Karen, Beth, and Laurie — all of whom live nearby. The youngest, Laurie, and her husband, John Lundquist, plan to take charge of the Barker Farm someday. In fact, they already have begun.

* * *

The Barker farmstand sets on Osgood Street (Route 125), a well-traveled road that runs between Haverhill and Lawrence. The highway was built in the late 1920s with rock from the stone walls of the Barker farm and others. A stream of traffic flows by constantly during the day, and it is from there that customers turn into the small parking lot in front of the Barkers' farmstand. In 1985 the family quadrupled the size of the stand. They added a greenhouse for tending bedding plants. They could spread out a little and carry more produce by working from a loading dock. The store building is red-painted wood, like a small barn, and inside are inviting wooden bins displaying the fruits, vegetables, and preserves of the season. It is open from Easter to Christmas, every day from 10 A.M. to 6 P.M. From Easter until strawberry season in June, Laurie and John Lundquist are business partners in the stand. From summer through pumpkins, Laurie and her mother have the business. John and Laurie take over again from November through Christmas.

You can get just about any seasonal produce you want at the Barker stand. The farm itself produces raspberries, summer squash, beans, apples, pumpkins, and the unrivaled sweet corn. Moreover John and Laurie go to Boston Market before dawn two or three days a week to stock up on other produce. A Salem confectionery delivers fudge and candy to the stand, a Lynnfield baker brings fresh breads and pies. Laurie keeps animals next to the stand — two sheep, four goats, chickens, ducks, two horses, and a rabbit — to entertain customers. She says it seems that about one in four people who come to the stand look first at the animals in their pens. "Last spring," Laurie said, "the Lawrence dog officer called me up and asked me if I wanted a baby goat. She found him on a rundown street in Lawrence tied up in somebody's yard. He was probably going to be somebody's Easter dinner. He was so cute. We got him on Good Friday, so that's what we named him: Good Friday."

Laurie looks solid and handsome, with thick, long, blondish hair. She is a kind woman who talks and laughs easily and modestly like her father.

I went to Keene State College for two years and took environmental science. I guess I was always pretty good at math and science, so I found that interesting. I transferred to UMass and was still in environmental science. But I didn't want to just work for some industrial company and check on their chemicals, so I changed to plant and soil science.

I think that going to college was something that I just did. I didn't really think about it an awful lot. I probably would have been a lot happier if I had just stayed on the farm and started way back then. But I learned a lot. Especially after I switched to plant and soil science; I really enjoyed that. I learned about small fruit production and a lot of things that my father did which I just didn't understand.

While I was in college, my sisters had already been out of college and had the opportunity here before me to jump right in if they

wanted to. But they decided not to. If they had, I don't know where I would be now. So I'm kind of glad they didn't. I've always loved it and appreciated it here and didn't mind the work as much as they did.

At the time, though, it didn't seem like there was an awful big opportunity here, because there was only a business for five months in the summertime; what would I do all winter long? So it really never dawned on me. The first summer I got out of school I worked with my mother. Then that winter I didn't really know what to do, so I just got a job at a place that had about twelve horses and helped a lady take care of them. Everything else just fell into place from there, meeting John, and taking one step at a time.

I always wanted to marry a farmer, but John worked at Honeywell. When he had vacations from Honeywell, or after his workday, he would come help me at the stand. He just kind of learned all the ropes. He had some background in the farmstand, because his brother had one up in New Hampshire a few years ago. So he fit right in. This was six years ago. So we got married. He was still working at Honeywell, but they had a layoff. He had already thought about working on the farm, so he volunteered for the layoff and did what he could here.

In past generations this farm could raise all kinds of crops and sell them all, too. Now, the Barkers have chosen to specialize in a few crops they believe will sell well locally. George decides what to grow on the 200-acre Barker farm. The products now are milk, sweet corn, raspberries, apples, pumpkins, wood, and some garden vegetables.

Usually I sell two bushels of sweet corn out to other farmers for every one bushel here at the stand. That's ideal. Then I can always keep plenty of corn coming along so that we never run short.

A lot of it goes right here in Essex County, sometimes to New Hampshire. The early part of the season, we sell to New Hampshire, when New Hampshire corn isn't quite in yet. At one time we had a fellow coming up from Rhode Island to get it, but I don't have anybody coming that far now.

Sometimes we swap. In other words, sometimes I'll run out of sweet corn, and I'll call somebody and maybe they can supply me. A lot of times people call me and I can supply them when they are short of their own corn.

Raspberries, we wholesale similar to corn. Not a lot. We put two-thirds of the crop at the stand and sell one-third wholesale, or maybe even three-quarters at the stand and one-quarter wholesale. The other vegetables we just raise what we think we can take care of, which really isn't very much.

I've given up raising strawberries. We now go to a pick-your-own farm and pick them as we need them. It's very nice to get just the amount that you think you want. One of the problems with strawberry production is you never have enough until all of a sudden you have twice too much. But there were strawberries here up until about six years ago. We replaced them mostly with pumpkins. We do raise quite a few pumpkins.

We raise summer squash. I gave up raising winter squash, because it seemed to me I was putting as much into the squash as I could buy them for.

And the apple orchard was reduced. We still raise most of our own apples, except for a few varieties. At one time, I guess we had 400 trees, and it's down to maybe seventy-five old trees now. I have put in some young trees, so that there are probably about 150 or 175 trees out altogether. This nice new Paulared early apple starts in August, and we get apples until the Baldwins. We usually finish picking those about October 15.

We do sell quite a few pick-your-own apples. It's been about six years now that we've been doing that. Started out quite light. Of course, we're not ideally situated here for pick-your-own, because of the highway and parking facility, which isn't quite big enough for a serious pick-your-own operation. I don't think we really want to get into a big pick-your-own operation. We don't do a lot of advertising for it. We put a sign out on the street and that's about it. The labor requires extra from what we already have, because we're already busy at that time with sweet corn and the stand. Pick-your-own is less labor as far as the harvest is concerned, but you have to have some supervision. It isn't always easy to have somebody that is capable of running that kind of an operation and supervising people. We could get kids to do it, but we hesitate to do that.

And we sell wood. Of course, wood grows pretty fast, so we've been just trimming around the fields, generally. And if we want to expand the fields, sometimes we clear the land and get the stumps pulled out. So we usually have a fair amount of wood supply, but there again, that's a situation I don't want to get into very seriously. It's almost nothing but hard labor. Make a new dollar for an old one, and maybe you can buy your wife a little present, besides.

Meanwhile, George Barker and his dairy manager of more than twenty years, Russell Whitney, milk about four dozen Holsteins and care for thirty or so young cattle. It has been a relatively reliable and profitable business for most of that time. George took the dairy, and the rest of the farm as well, through its mechanization period. His father had been accustomed to working with hand tools and horses and the machinery they can draw. As his father had done, George decided to move slowly from one technology to a newer one. He redesigned his dairy barn to accept the less-labor-intensive milking parlor operation only after he was

satisfied that the technology had proven itself elsewhere. But he has not introduced a mechanized corn picker, for example, because he prefers hiring youths in summer to help pick corn. The leftover stalks can be fed to the cows. A mechanized corn picker does not leave much fodder, George says.

The New England dairy industry has seen tumultuous swings in recent years. A dairy farmer has tussled with a decline in the consumer's desire for milk products, changes in the products themselves, and rising costs of fuel, machinery, grain, taxes, even baling twine. As dairy farmers all know, they buy supplies at retail prices and sell their product wholesale. Our need to keep them in business allows the federal government to subsidize the price they get for milk. Yet even in such a business, as George Barker looks at the books he keeps for the farm, he is doing all right on the dairy side. What has kept him in the dairy business, he says, is "stubbornness."

A dairy farmer seems to have kind of a steady income right now. Not high, not usually too low — sometimes too low — but usually about average, enough to keep going and doing what he wants to do.

I do get some government help. I've had some programs in the past, and I usually have a cover crop program every year. But as far as major income is concerned, there's no way in this area that you can come anywheres close to enough of a benefit to pay for going into it. You can't get enough of a payment to do what some of the other farms in the rest of the country are doing. For instance, if you had 2,000 acres in this area, you might be able to do something. But with these small farms in this area, it's just not worthwhile.

As far as I'm concerned, the federal government, by subsidizing milk and making federal orders, has stabilized the milk price sometimes too low, sometimes fairly, but hardly ever too high, since it was

installed in 1932. I think the milk industry would be in chaos if it wasn't for the federal orders.

This recent federal farm bill is almost a confirmation of that, because they have gone into a one-price milking system for the whole country, and New England just can't survive that. Vermont has already taken steps to supplement the dairy farmers' income. Massachusetts is contemplating it in the form of an added eight-cents-a-gallon to the consumer, which will be paid back to the Massachusetts farmer. As far as I'm concerned, if this program doesn't go through, the future of dairying in Massachusetts is going to plummet, because the dairy farmers that are in it, like me, may stay awhile with lower prices than they should be. But nobody can start in and build a herd up with the prices that are projected for the next few years.

We in the Northeast pay more—more for grain, more for everything, more taxes, more everything—and we just can't survive on a one-price system.

The size of a dairy farm isn't a disadvantage. If you could get low feed, feed at a low cost, you could survive. You could have it shipped in rather than raising your own. This is true all over New England; it's not just Massachusetts. As I say, Vermont has already put into place a program to add to the dairy farmers' income.

Support from Massachusetts government in recent years has been really quite surprising. They have seemed to realize that something desperately needs to be done, and they have taken several steps to help us. Whether this bill will pass—and, of course, some people consider it a tax. But it isn't really a tax, it's a set-aside for Massachusetts farmers from all the milk that is sold. The opponents of it call it a tax. So perhaps that will be enough to keep it from going through. But as I say, there is supposed to be another fifty-cent cut January first. Now, the milk shortage of this year has raised the price of milk to a reasonable level, but another fifty-cent cut and we'll be right back down again.

I definitely benefited from some state programs. Chapter 61A—which is the farmland being taxed at its use value, rather than its highest invested value—has saved many a farm from being sold. There wouldn't be any agriculture within fifty miles of Boston, I dare say, if it wasn't for that. That went in, it must be twelve years ago now.

*　　*　　*

Like all farms in this part of Massachusetts, the Barker place is surrounded by urban sprawl. An adjacent farm sprouted some sixty houses in the early 1980s. Down the hill on Route 125, an industrial park and a massive AT & T Network Systems plant, protected by chain-link fencing and security stations, are spread out on land which not long ago was a farm. Small propeller planes overhead are a constant reminder of the Lawrence Municipal Airport across the road.

The lure of selling land for real estate development in this area is hard to resist. Thirty years ago, George Barker sold some of his woodland for five house lots as a means of relieving hard times in the dairy business. It was wooded land that he wasn't farming anyway. "We got peanuts for the house lots," George says now. "But, of course, that long ago it wasn't quite peanuts. It seemed to satisfy me for quite a few years."

In the mid-1980s, his sister sold thirty acres of the farmland she had inherited, and there are houses now in that meadow. "That was really very sad to see go," Laurie says. "There was a really nice swamp back there, and a lot of birds. The top part was a great big cornfield. But I can't blame her. She wasn't getting a lot out of it, and she lives in Hamilton."

When it comes to the disposition of land, Mr. Barker is as

smart as they get. He has inherited the Barker ability to think creatively about passing on property in the family. And he's been an assessor in North Andover for sixteen years, so he knows about land values and uses. George himself recently became a developer of sorts by building a fifty-six-unit duplex condominium development on some back land. One reason he did that, he says, is to use that land to his tax advantage, land that otherwise could be taxed as residential real estate. And he has placed fifty acres of land in a trust for his four daughters. It cannot be sold unless three of the four agree to sell it. It is a gift that is not subject to estate tax.

You look at all this land, and you think it's worth a lot. My thinking was that the Internal Revenue Service would also think it was worth a lot and would want a very sizable chunk of cash to keep it as a farm and in the family. . . . An awful lot of farmers are not taking this into consideration. Farmers just leave their land when they pass away and the family is left with the estate tax.

I have tried to take care of the rest of the farm with insurance. And I have started that development of duplexes. So hopefully that will take care of another good chunk of it, and there won't be too much left that the Internal Revenue wants. I don't quite believe that, but that's what I hope. But when they set the rules, I will certainly do my best to keep them from forcing a sale of the farm.

The first farm that went out that I remember was probably thirty years ago. The father died, and his two brothers were farming. One of them decided he didn't want to farm. So the farm had to be sold. The brother that wanted to stay could not. Just couldn't afford to. It could have been avoided, I'm sure, especially looking back on it. It could have been set up that perhaps they both would own the farm together, but they both would have to want to dispose of the farm before it was disposed of.

From the looks of it, the Barker farm will continue well into its tenth generation. George is not exactly thinking of retirement. "Retirement wouldn't be any different than what I do now," he says, grinning. "I would still get up in the morning and have work to do."

But he is relinquishing more of the planning to Laurie and John. He offers them his observations on the trends he sees.

It's harder and harder, because especially for summer crops, it's such a short season. There are vegetable growers who have been seeming to drop by the wayside. So they've been getting into the flower business and plant business and the greenhouses more, rather than vegetables. As far as I know, they are the ones that have been doing the best in the past twenty years.

I would expect that there would be always an opportunity for a farmstand to continue and do pretty well here. Because of the growing population, for one thing. And the people want quality, and they're willing to travel a ways for it. We are, I think, in a pretty convenient location for quite a few people, which also helps. So there are three or four factors there that I feel contribute to the continuing operation of the stand. . . . Some stands get into specialized food areas, but I think Laurie and John will probably get into the plant business more than that kind of a venture.

Laurie listens to all this and comes up with ideas of her own.

The farm and the stand will definitely continue. The dairy business, maybe not. There's not an awful lot of profit in that.

Two of my sisters and I really like horses a lot, so maybe the pasture land can turn into some of that. Dad won't be too happy to hear about that. But it depends. There are an awful lot of people around here who might be interested in boarding horses. That's just another

thing that will have to fall into place one step at a time. I don't think we're the kind of people who will just go ahead and do something if there's not really a call for it. We like to start small and just be cautious along the way.

We're going to have to make the farmstand bigger sooner or later. We'll have to keep it the way it is for at least another year. Then maybe we can add an area for fresh flowers. The people who bring us fudge and candy say that we could sell an awful lot of candy if we had a little candy shop. And the bakery says we can sell more baked goods if we had more room for it. So we'll have to wait until there's a real need for it. We could try to bake everything ourselves and try to make all the candy, but we would be so strung out. We let the experts do it.

George Barker believes that the farm, by and large, has carried on because of certain fortunate occurrences. Through the generations, family members have been dedicated to the place, and those circumstances continue today. George Barker attributes his prosperity and satisfaction to the devotion of his wife and daughters. His own self-effacing diligence surely has had something to do with it, too.

You have to realize that when you're talking about a sizable chunk of money, which most farmers have when they die, greed is a normal human trait. "What's mine is mine and I want it now." There are so many young farmers that have worked with and for their fathers, and then other family members will come in, and they're out of business.

You have to have special circumstances. You have to have special people who want to make a commitment. You have to have special talents. One of the worst things is to have someone pass on their farm without any provision for the person who has stayed there and run the farm with them, or helped them run the farm. And others in the

family will come in and want to share the farm, and it has to be sold. That is the saddest situation, as far as I'm concerned.

Sometimes there's no one that wants to take over the farm. That's not such a heartbreaking situation, but that takes care of quite a few farms right there, too.

Then you have someone who thinks they can go out and buy all the fancy equipment in the world, or wants to spend a little time farming and spend a lot of time watching the soaps or something like that. And they don't make it.

You have to know what you're doing and do it properly, or there's really not much sense in doing it.

Haying was always a very busy time. Sometimes when sweet corn was in, we'd be working from 4:30 in the morning to 9:30 or 10:00 at night.
—GEORGE BARKER

When [the IRS] sets the rules, I will certainly do my best to keep them from forcing a sale of the farm.
— GEORGE BARKER

Sweet corn was all white, I believe, before 1930. My father was one of the first ones to grow yellow sweet corn.
— GEORGE BARKER

Working the way I did made you a pretty rugged kid, and you really didn't have to take much guff from anybody else.
— GEORGE BARKER

70

My mother [Dorothea Barker], John, and I are all stand managers. We all get along real good and talk about problems and come to solutions between the three of us.
—LAURIE BARKER LUNDQUIST

We often get comments like, "You have the best corn in the state," which is nice to hear. — GEORGE BARKER

Especially when we are getting ready to close [the farmstand] for the winter, we hear a lot of people say, "We're going to miss you so much." — LAURIE BARKER LUNDQUIST

One of the worst things is to have someone pass on their farm without any provision for the person who has stayed there and run the farm with them, or helped them run the farm. — GEORGE BARKER

Russell Whitney has been dairy manager at the Barker farm for more than twenty years.

At one time, I guess we had 400 trees, and it's down to maybe 75 old trees now. — GEORGE BARKER

Even though it was long hours, I enjoyed the work because it was outside and because it was always different. — GEORGE BARKER

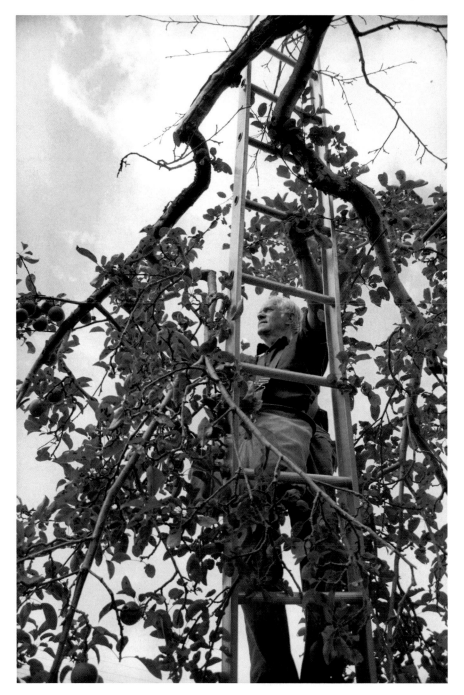

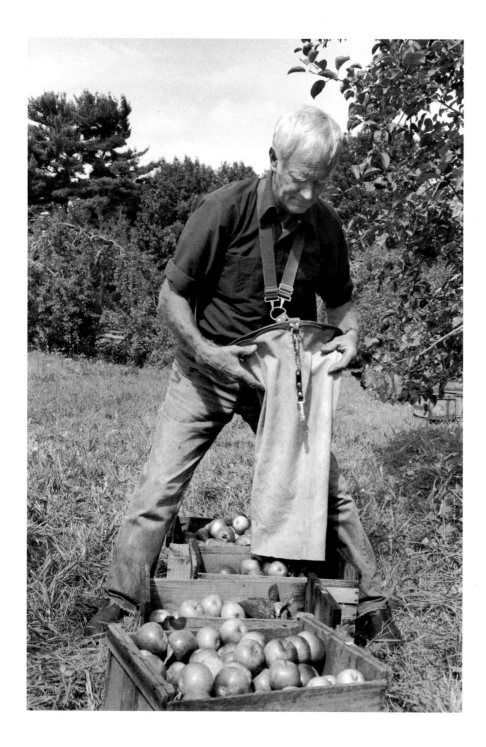

This nice new Paulared early apple starts in August, and we get apples until the Baldwins. We usually finish picking those about the 15th of October. — GEORGE BARKER

I never wanted to work for someone else. — GEORGE BARKER

This valley land is outstanding. We can farm it whether it's dry or wet. It's still a good crop. — "FLASH" GORDON WILLIAMS

"We're on soil where a lot of us have been before."

Luther Belden Farm, Inc.

NORTH HATFIELD
Founded in 1719

Luther Belden came home to the family farm in 1929 after four years studying animal husbandry at Purdue University. His father, George, and uncle, Oscar, were among the biggest farmers in the Connecticut River valley of western Massachusetts at that time. They grew more than 200 acres of potatoes and onions and had arranged to buy much of the produce raised on nearby farms to market along with their own. The Belden farm of North Hatfield also claimed the biggest flock of sheep in the East. The autumn when Luther returned to the farm, Wall Street crashed. Business everywhere went sour. And the Belden farm turned into a big farm with a small market.

As the Depression set it, Luther married Evelyn Ladd. That was as good for the farm as it was for him. Evelyn had just graduated from Mount Holyoke College in South Hadley, downriver a

few towns from the Belden place in North Hatfield. The daughter of a Vermont banker, she was very gracious, already a good cook, and eager to get involved in a Massachusetts farm.

They lived in "the house across the road" from the main farmhouse. Their daughter, Mary Louise, was born there in 1932. After Fred was born in 1935, the house across the road was too small, and Luther and Evelyn and the kids moved back across Depot Road to the main house where Luther had been born, the house his grandfather Belden built in 1865. In keeping with what had become the pattern, Luther's parents moved to the place across the road.

To forestall bankruptcy in 1934, Luther and his cousin Clifford agreed to take a big mortgage and buy the farm from their respective fathers, George and Oscar.

Luther concentrated on the livestock side of the business. Right after college he had taken over the big-time sheep operation of the Belden farm. Luther's great-grandfather, Oscar E. Belden, began raising sheep here in the mid-1800s. Later, Luther's father introduced the Southdown breed which won prizes at all the agricultural shows and became nationally famous. These were sheep who would spend summers twenty-five miles north in the sixty acres of hilly grazing pasture the Beldens owned in Colrain. They would graze in the highlands in summer, Evelyn explains, because "it's too warm down here."

We had a sheep man who would drive them, walk with them, all the way up there. . . . He would walk them from here to Colrain. It would take him one full day. All the people on the way used to watch for him. He would go the back roads. . . . He had a wonderful sheepdog. And that sheepdog was champion at Chicago, too. If you've ever seen sheepdog trials, it's wonderful what the dogs can do. At

Colrain, which is all hilly, the man would stand on one hill and whistle, and that dog would do whatever he told him to.

In the fall, Luther would load about a dozen of these Southdowns on the train at the North Hatfield depot for the trip to Chicago's International Livestock Exposition, just as his father had done. In Chicago in the late 1920s, the Beldens won the prize for the best Southdowns four years in a row, retiring the trophy which had long been in competition.

At that time, Luther Belden Farm was regional headquarters for a wool pool. Local sheep farmers would transport their wool to North Hatfield where the Beldens kept records of it all; big trucks came to haul it away. The family still has blankets they acquired through the wool pool.

But trophies and reputation were not enough to sustain the farm during the Depression. Selling lambs for Sunday dinner tables got the Belden farm through the 1930s. Luther's flock of Dorset Delaine lambs pleased the palates of city people. By the 1940s, Luther and Evelyn Belden were running "hothouse" lambs to New York City every week. Evelyn remembers the trips.

They are lambs six weeks old, about forty pounds. Boston did not take hothouse lambs. They wanted fat lambs. They didn't want those small lambs, but New York did, and that was more profitable. We transported them to New York every week from Christmas 'til Easter. At Eastertime we'd use a truck and take down lambs which other people in the area would bring here. They brought their lambs here to be slaughtered. We had a slaughterhouse out in the barn, and at Eastertime we'd slaughter about 200 and take them to New York.

We had a wholesale place down on little West Twelfth Street where we took them. But we also took them to some of the best restaurants.

Luther Belden in 1947 with prize-winning Southdown sheep

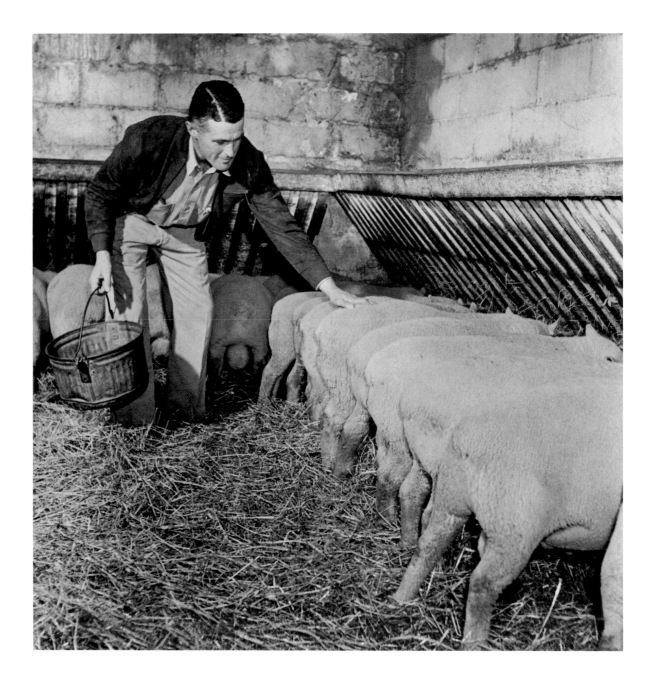

We would leave here at two o'clock in the morning and get there at six o'clock, then at eight we would leave to come home, and we were home at noon.

We took them down in a station wagon. They were all slaughtered. You could get maybe forty in a station wagon. It was fun! We got stopped on the Merritt Parkway for "commercializing" the parkway one time. Of course, you wouldn't think they'd know — the lambs were all covered up — but they stopped us because the back of the station wagon was sagging, and they were looking for a stolen safe. They found out we were transporting lamb. After that, we had to go on the Connecticut Thruway.

In the 1940s, Belden Farm was a storybook Massachusetts farm. It was 200 acres of Connecticut River valley cropland, possibly the best in the state. The Belden family (formerly "Belding") had been landed Yankees here since the late 1600s, always a stalwart influence in the Hatfield government, the Congregational church, and the schools. There was no sign that any of that would change in the 1940s, just as there was no such sign a century before. Luther was a town selectman and finance committeeman, a church deacon, trustee of the county Cooperative Extension Service, officer in sheep breeders associations. Evelyn headed 4-H clubs in knitting and cooking; she was in charge of the church's Sunday school and head of the local book club. Grandfather Belden tended the huge garden. The farm was producing 20 acres of fine cigar-binder leaf tobacco, 10 acres of cucumbers, 100 acres of potatoes, as well as more than 300 sheep, the famous Southdowns, and the hothouse lambs. They had two full-time farmhands, and in summer and fall employed as many as twenty people among the predominantly Polish families of Hatfield and neighboring towns.

In fact, the Belden family was depicted as the happy, prosperous, modern farm family in the July 1947 issue of *Country Gentleman*, a magazine of upwardly mobile rural Americans. The photographs show a handsome, square-jawed Luther Belden with his wife, Evelyn, her mother, Grandma Ladd, and three of the children grinning around a Monopoly game; there is Evelyn teaching a Sunday school class, and there she is in town, with her teenaged daughter Mary Louise, examining a new electric mixer; there are the Belden boys playing baseball; there is Luther showing off wool, and Evelyn canning fruit.

* * *

At just that time, Gordon Williams was attending the Stockbridge School of Agriculture nearby at Massachusetts State College in Amherst. He came from another longtime Connecticut valley farm family, the Williams family, just across the river from the Belden farm in Sunderland. His buddies called him "Flash Gordon." Their Saturday night fun was the square dance at Hatfield town hall. Flash met Mary Louise Belden at one of those dances in 1950. She was about to graduate from high school and was seven years younger than Flash; they say today that they both could foretell a romance.

Mary went off to Colby College in Maine. Flash joined his brother on the farm in Sunderland. The romance was "on and off, on and off" for four years, Mary says. Trying something new and different, Flash joined the U.S. Forest Service. He was sent to California, which made it even harder to stay in touch with Mary. But they had decided to get married anyway, and in 1959 Gordon Williams married Mary Louise Belden in the Hatfield Congregational church. You'd think they would have had a place to farm in

Luther and Evelyn Belden with three of their children and Evelyn's mother, Grandma Ladd. The 1947 photographs were for that year's July issue of Country Gentleman *magazine.*

Grandma Ladd with Sanford Belden, 1947

the Connecticut valley, but Flash's brother was on his family's place, and Mary's parents were on the Belden place.

So they went West. Flash pursued his college studies in dairy husbandry at California Polytechnical Institute; as a California resident by this time he could attend tuition-free. Mary taught second grade in a local school. Two sons were born, Darryl in 1960 and David in 1962. By the time he graduated from Cal Poly, Flash had decided to be a farmer in the Golden State.

But things didn't work out quite as well as I had anticipated. One of the things that I didn't like about farming in California was that on most of the farms you're milking cows or you're raising crops. A lot of the farms out there buy all their feed. And, of course, they're large farms, so I couldn't see that there was an opportunity to buy a farm out there because of the size of the operation and the fact that you had to have a milk market in order to ship milk, which meant you had to buy the contract in order to sell milk.

After I graduated in 1963 from Cal Poly, I went to work on a farm in Potter Valley, which is near Ukiah. This is sort of a poor area. They raise a lot of pears and grapes. It's not very strong in dairy. I worked there for about two months, and things didn't go too well. The man I was working with, we didn't see eye to eye, so I was sort of stuck in that area. Mary's father invited us to come back here, not necessarily to farm here, but because we were in an area that we couldn't see any future. We just packed up and came home.

Mary and Flash lived in the main house with her parents for a short time, then they moved to the house across the road, where the grandparents Belden had lived, and where Mary was born. Mary Louise, the Belden girl of North Hatfield, was back home. Before she and Flash left for California, she had been trained to teach at the Clarke School for the Deaf in Northampton, and she

had obtained a master's degree from Smith College. Her brother Sanford, a 4-H sheep breeder as a youth and now fresh out of Purdue, was interested in keeping the sheep at the place, but he decided a year later to pursue other work and now is with the Federal Land Bank. As the sixth generation Mary Belden on the home place, Mary Louise was back to raise a family and carry on the farm.

I guess in a way I had mixed emotions, because I was happy to come back to the place where I had grown up, but to come back as a married person with a family was quite different from being a young adult going to school. So I knew that my role was going to be very different. But at first, I think, I did have mixed emotions about it, not being sure it was going to work out. But it was fine. Everything worked out pretty well. The people I knew as a child growing up had either left home or married and stayed in Hatfield. My school friends, for example, were, for the most part, not here. As a married couple, then, we made different friends. So it worked out fine. I think I was happy to be settled, finally, because we had moved several times, and then finally decided this was what we were going to do.

Careful conveying of family property seems to be a trait carried on in this family since the seventeenth century. A look at the seventeenth- and eighteenth-century wills reveals some of the detail that Belding ancestors applied in order to avoid any confusion about who would gain title to specific portions of family land and property. The weight which has accumulated on the Belden farm for more than 200 years now requires its operators to handle it with care. But the decisions that have determined who becomes caretakers lately have been made more on the basis of the size of the place, and its relative financial condition, than on any sort of family heritage. Luther was his father's only living son when he came back to the farm that was owned jointly by his father and

An Inventory of the Estate of John Belding of Hatfield Deceased taken y 12th:
Day of January 1725/6 by Serj't Nath'll Dickinson Jonath'r Smith & Jonath'r Morton

	£	s	d
Six paines in Mancy 5/ A hat 20/ another hat 7/	7	17	4
A great Coat 5/ A new Coat 45/ A Coat 18/ an old Coat 7/ A New wast Coat 58/	5	4	3
An old Grey wast Coat of Serge 7/ an Old Yellow wast Coat 7/		14	4
A pair of linen breeches 4/ another pair of linen breeches 4/		4	4
A fine shirt 7/ A finer shirt 9/ A fine Muslin Neckcloth & band 4/		18	4
A Checkered Silk Neckcloth 4/6 A pair of Gloves 2/6		7	4
A pair of bluish Stockens 1/6 A pair of bluish Stockens 4/		5	6
A pair of Grey Worsted Stockens 5/ A pair of Boots 5/		7	4
A pair of Shoes & buckles 5/ A New Checkerd Coverlid 42	2	4	4
Another Checkerd Coverlid 42/ A Spotted Coverlid 25/	3	5	4
Another Spotted Coverlid 23/ A Checkerd blanket 20/	2	3	4
A Bed 5/10 Viz A New bed A New bolster 16/	6	6	4
two New Pillows 17/ an old bedtick 5/ Ano'r Old bedtick 7/	1	11	4
A Bed 5/ A bolster 13/ an old linen under bed 2/6	3	16	6
A Yellow french Coverlid 14/ an old Coverlid 6/	1	4	6
An old streaked blanket 5/ an Old small blanket 2/6		7	6
A Yellow Checkerd blanket 20/ another Yellow Checkerd blanket 20/	2	4	4
A thick White blanket 9/ A streaked blanket 12/	1	1	4
An Old Coverlid 2/6 A bed 5/10 A bolster 16/ an under bed 11/	5	12	6
A Yellow 5/ A Set of Curtains 50/ A bedstead 10/	3	5	4
A Bed filled partly with hair & part with feathers 1/15	1	15	4
A bolster 11/ A Grey Coverlid 11/ ano'r Grey Coverlid 11/	1	13	4
A good streaked blanket 17/ another streaked blanket 17/	1	14	4
An Old streaked blanket 5/ A trundle bedstead 4/		9	4
A Bear Skinn for an Under bed 7/ A Cord 1/		2	4
A Bed filled part with hair & part with feathers 54/	2	14	4

A Bolster 9/

Portions of the inventory of John Belding's estate, 1725

uncle. Buying it with his cousin made financial sense during the Depression. As Luther and his cousin Clifford continued in business together, they considered provisions for future control of the farm.

Mary Louise remembers that there was never any pressure on her and her siblings to plan for assuming the farm. All they planned was to go to college.

I never had any idea that I would ever marry and come back to this farm. Even when we were in California, it wasn't anything my father said, you know, "Boy, we'd really like to have you come back," because Dad never said anything about that. They let us lead our own lives. . . . I don't remember as a child that we ever had any discussions about what was going to happen, what would happen, what would be the future. Like any kid, you just live day by day, and you don't think about what's going to happen to this place. We heard stories, yes. But only personal stories. Not stories that would make you feel that, "Gosh, somebody — one of us — ought to stay here." And I guess it was the furthest thing from my mind that I, the daughter, would be the one who would come back to the farm.

What Luther and his cousin Clifford had done fifteen years before Mary and Flash returned was to split the place in half. Clifford's family was older than Luther's and was ready to become involved somehow. The cousins separated financially to preclude what could have become a complicated succession in the family. When Flash and Mary returned to the place, Luther and Evelyn incorporated the farm to prepare for the next generation. Flash Williams appreciates that.

What it meant is that it would be an orderly transition between generations. I think there was a concern by my mother-in-law and

Headstone of John Belding (1669–1725; family name now Belden) in Hatfield's Hill Cemetery

father-in-law that the farm would not be carried on, and I think that they felt that in order to make a smooth transition, that it would be advantageous to incorporate. When the corporation was set up, a portion of the stock was given to Mary and me, and the rest of the stock was held by Mary's father and mother. There was a small portion of five shares apiece given to her younger sister and two brothers.

We've since bought out the shares of Mary's sister and two brothers. I think this was largely due to the encouragement of Evelyn [Belden], because I think she was concerned about how things were to be left. . . . She was very concerned that the family not have to fight over the farm, and they felt very strongly — my father-in-law, as well, felt very strongly — that whoever decided to stay here should have control of the farm.

Luther figured that the New England dairy business was growing well enough by that time to allow Belden farm to expand in that direction. There had never been a dairy on the place. And here was Flash Williams, both experienced and schooled in dairying, who was also married to his daughter. Flash set out to establish a dairy herd. He bought some cows from Indiana and others from New York, and he built a cow barn. The idea was to blend the dairy business gradually into the rest of the Belden operation.

The next year, 1966, Luther Belden died unexpectedly. Flash was just getting his fifty-Holstein dairy underway. The farm was producing potatoes and cucumbers in addition to hay and corn for the cows, with the Southdowns and hothouse lambs still going strong. "It was a big adjustment for me to suddenly be in charge of things," Flash remembers. "I really wasn't prepared too well on the financial side of it." He and Mary had three young boys, and their daughter, Mary Ruth, was on the way. Mary remembers it as "a three-ring circus."

The potatoes and the Southdowns went first. For about four years they continued the lambs and some ten acres of cucumbers which were sold to the Oxford Pickle Company in South Deerfield. As the dairy became more profitable, they turned most of the farm into crops for expanding that part of the business — alfalfa, hay, corn. The farm saw major changes during the late 1960s and the early 1970s. Flash converted the farm to an all-dairy operation which could grow everything it needed. Mary returned to teaching at the Clarke School for the Deaf. Evelyn went to work at the Smith College Registrar's Office. And, the surest sign of transition: the Williams family moved into the main house, and Evelyn moved across the road.

* * *

Another house across the road fits into the history of the Belden farm. It is what Evelyn calls "the little white house." Families of Belden farm workers have lived in it. Luther and Evelyn usually had two full-time men who took care of the cows which supplied milk and butter to the family, drove the horses, and were mechanics and field hands. Flash and Mary have had two employees, also, who have lived in the little house.

But the part-time seasonal helpers really characterized this farm. At one point in recent memory, more than twenty-five people would be at work here. In the onion fields during the first part of the century, local Polish families worked the crop "to halves," Evelyn says, deriving half the proceeds from the big Belden crops. The August tobacco harvest brought in lots of kids, including Belden cousins visiting for the summer, who hung

tobacco leaves on slats and loaded them onto wagons in the field, then hung the slats in ventilated barns, and finally went swimming in a pond. On the best misty day in November, local women came for the "tobacco damp," when they stripped the dry leaves from their stalks and piled them for buyers.

Somehow the cucumber crews were the most memorable. They rode low along the field in a rickety contraption that creeps over the cucumbers. Evelyn Belden sparkles as she remembers the cucumber crews of the 1940s and 1950s.

That was what my youngest daughter, Martha, did. She was on the cucumber picker all summer. . . . There were eight kids who'd ride on their tummies and pick the cucumbers, and then there was one who dumped into the bags. Took about ten kids. We had neighborhood kids. Some of the time I went to Northampton twice a day. We had two shifts so that I'd have to go get them in the morning, take that shift back, and get the second shift, take the second shift back. . . . They were as young as twelve, some of them. In fact, the younger ones were apt to be better than the older ones. They weren't quite so bored.

My younger son, Sandy, did that, too, but he and his friends would make up all sorts of games that they played. Word games or something like that while they were picking. Martha objected to always having the back of her legs tanned and not her front. It was a very boring job. I did it during the noon hour when they would be short-handed. It's very boring.

But we did have a couple of marriages that resulted from the cucumbers, kids working together in the cucumbers.

Mary took charge of the cucumber kids when she and Flash assumed the farm. She sent her own boys out there, too. She paid the best pickers sixty cents an hour.

Young Darryl was the first Williams boy on the cucumber crew in the 1960s. He remembers helping his grandfather Luther as a five-year-old.

We used to have an old cucumber picker. It didn't have a conveyor belt, it had buckets. As you filled up a bucket there was always someone that would take that bucket, give you another one and put it in a burlap bag. I can remember helping my grandfather on that.

* * *

Now age thirty, Darryl is a full-time working partner at Belden farm, a shareholder with his mother and father. His two younger brothers and little sister, Mary Ruth, have not committed themselves to the farm, "but we still call them if we need help in one project or another," Darryl says. David is a mechanical engineer with Raytheon and lives with his family in eastern Massachusetts. Brian is five years younger than Darryl and does air-quality control and site preparation for an asbestos-removal firm. He and his wife live nearby in Deerfield, and he has talked about an interest in the family farm. And Mary Ruth is a young registered nurse.

The storybook aura of the Belden farm continues into the eighth generation, which Darryl represents. He and his wife, Lucinda, met at the local school and were married after college in 1984. Their children — Rebecca is four and Jackson is two — are lively, handsome children who love the four mornings a week they have with Great-Grandma Belden. They attend the Congregational church. Lucinda sews beautiful clothing and quilts. Over and over, Lucinda marvels at the family all around them on a farm where the children can learn about families and animals and plants and weather.

And the kids get to be with their dad. They can go out with him a lot. Of most of our closest friends, the wives either work at home or work a shift where they can be at home with their children. And they don't really know their fathers. The dads can't enjoy it like Darryl can. Every day I think how lucky our children are. He's there every day for lunch and brings the kids home. And they love to be outside with him. One day not too long ago I came home from work and got changed and Darryl was getting ready to go back to work, and both my kids are crying at the door, "Daddy, Daddy!" They just wanted to go with him. And they can often do that. We have tractors with the cabs, so they can ride in there. That's safe and they love it.

Lucinda's father, Gene McMurtry, was a pioneer in the Co-operative Extension Service. He established it in Virginia and then assumed the directorship at the University of Massachusetts, the oldest Extension Service. The McMurtry family lived in one of the big houses on Hatfield's magnificent Main Street. The family knew Flash and Mary Williams. As Luther had been before him, Flash was a trustee of the Extension Service in Hampshire County. Darryl Williams and Lucinda McMurtry just blended together, Lucinda says. They knew each other in junior high school and high school. Lucinda would think of Darryl then as "the kind of guy I wanted to marry." She hoped someone like Darryl would enter her life later.

I was in high school, and I didn't want to marry him while I was still in high school. So we both went to college. I went to Missouri and Utah, and Darryl was in school at Westfield State. We would see each other at Christmas and summer. I transferred back to Smith College, and Darryl was teaching. It was different from high school, but it was nice.

So we decided to get married, and I was going to marry a teacher.

I thought this was ideal: home at three o'clock and weekends off and summers off. I knew he loved farming, and he could farm all summer. And that's a good, healthy way of life. So I was going to marry my teacher husband. Surprise, surprise.

Everybody thought Darryl would be a teacher and coach sports. That's what he was good at. He has an easy personality, immediately trustworthy to children, determined to have them learn something. He is an athlete who played four years of soccer in college and he coaches the local high school team today. But during the year after college when he was teaching an autistic boy named Kenny, Darryl yearned to be outdoors. He would be working with Kenny and together they would look outside to a field they could see. "I always wanted to be out there on a tractor instead of inside," Darryl remembers.

As a boy, Darryl always seemed naturally interested in the farm. His grandfather Luther was impressed with little Darryl when the Williamses first moved to the farm. "He was just a bundle of energy," Flash says. "He knew all the different enterprises and the things that were going on." At age eleven, Darryl was proud to know how to load a wagon by himself and to feed the cows. He attended a few farm conferences with his parents, and once in a while they would talk about how it would be for Darryl to be a farmer. He remembers a time at the dinner table one evening when they were talking about the farm, and his brother turned to him and said, "It's you. You'll be the one to take this thing."

Flash and Mary, like Mary's parents, concentrated on opening all lines of endeavor to their children. They planned for them to attend college. They were host to foreign exchange students at the farm. At one point, Flash remembers, "I sat them all down and told them that if anybody was interested in coming back to the

farm, I'd be interested in having them do so, but I wasn't putting any pressure on them. This was completely up to them, whether they wanted to or not. And after a year of working with an autistic child, I think Darryl decided that he wanted to work outdoors. He really wasn't an indoor person."

I'm very interested in seeing him carry on the operation, and I'll make it as easy financially as possible. I'll turn over stock to him so that he can continue the operation.

It's just a matter of commitment. We're committed to keeping this farm going, as long as there's someone that wants to do so. I didn't pay to get into this operation and I don't think Darryl should have to, either. That's the reason it's been carried on from generation to generation. It passes down through generations. I think that one of the reasons young people haven't farmed is because their fathers haven't given them the chance to do that, which is unfortunate. They just didn't make it easy financially for them to take over. A lot of farmers look at their farm as a means of retirement, so they want to get paid for whatever they build up through the years. And that's not always easy for someone who wants to take over an operation.

Darryl's mother knows another attraction her son has had to the farm.

There's a very strong feeling among the family members, as far as the continuity of the farm is concerned. I think that our kids felt that being a part of something that was more than 200 years old was something pretty exciting. It's very strong, a strong underlying force. I think regardless of the age of the farm, there is that feeling that we're on soil where a lot of us have been before.

As Darryl says,

This is the same land that my father walked, my grandfather walked, my great-grandfather walked. It's grown tobacco, onions, potatoes, corn, alfalfa. The spirits of all those people are around here.

Now Darryl and Lucinda and their two children live in the house across the road. When Lucinda goes to work four mornings a week at the Smith College library, the children are with Evelyn Belden, who considers herself a professional baby-sitter.

Darryl and his father hire people to help with early morning and evening milking. Darryl's former student, Kenny, has been one of the helpers. After all, there are ninety cows to milk, and 180 acres of fields to tend. Flash wants to be "semi-retired" but can't quite work that into his life. As his son describes, the two of them plan out the work weeks together.

We try and talk in the morning to get a clue as to what the plan is for the day. We try to have some sort of a plan for what's going on during the week. I work with the breeder. I'm breeding cows. I work a lot with herd reproduction and herd health. I'm starting to get into paying the bills, although depending on what's going on it's an alternating responsibility; sometimes Dad will do it, sometimes I'll do it.

When it comes to field work, we both have our own set things we do. In the past years I've done all the plowing, and Dad's done all the planting. Dad harvests, he chops haylage and chops corn, whereas I take care of the silage pile and the haylage pile. I drive the truck. That's more or less what I am responsible for as far as field work. It works out well that our responsibilities mix together. Dad's a good mechanic; I try. It kind of depends on the piece of equipment. If it's something Dad is familiar with, he is in charge of getting it fixed. I

take care of a lot of the oil changes and filter changes on the tractor. That's kind of a shared responsibility.

Flash emphasizes the importance of running the farm as a business. He admits that when his father-in-law died suddenly, "I was really lost" in assuming the role of businessman. Darryl is catching on well, Flash says. "He doesn't like to spend any more money than he has to." Grandma Belden watches over things, too. She is the record keeper.

And Mary stays close to the farm work. During haying season, and often when corn is ready for harvest, she drives the truck. She is in total charge of raising the calves.

Lucinda feels it is just right.

With the four generations living right here in two houses, the kids know their grandparents and their great-grandmother, and they see them every day. It's the old way of life. Rebecca in the summer adores going out in the garden with Grandma. They were out there on their knees last summer, Grandma is eighty and Rebecca was three, and they just worked together. It was a great sight.

What a heritage I married into! Both sides of Darryl's family have lived on farms for over 200 years. His father's farm is right across the river, and his mother's farm is here. They've just been here forever. And they are good, hearty people who came when the country was new. And they have worked hard all their lives. And the same sense of hard work has been carried on all these years. Darryl still has that philosophy. It's an honest way of life. It's hard and always will be. But it's good and it's clean, and we know we do something that helps other people.

The family farms are really dying, and I am proud to live on a family farm. There's something good and wholesome about the way of life. All these generations and people have done it. We as a people
have become so removed and so caught up in money and things and material stuff that we forgot how nice it is. When you work in an office environment that is heated in the winter and air-conditioned in the summer, you forget that there is a whole world outside going on around you. You just miss so much of life. We get to see that every day here.

As Darryl and Lucinda grow more involved with the future of the farm, Flash and Mary have begun contributing more of themselves to the community. Mary is a member of the town school committee. They both serve in governing positions in the church. Flash lends to the town Conservation Commission and the regional Conservation District a vision he has for preserving the agricultural nature of the area. A few years ago, he and Mary sold the development rights to much of the farm to the state under the Massachusetts Agricultural Preservation Restriction program so that the land could not be sold or taxed for anything but agriculture.

The Belden farmland is prime agricultural land. Flash says the farm can grow all the feed it needs for maybe 150 cattle. Even now it can sell surplus corn. The land can grow a crop in wet seasons or dry seasons. As Mary says, "it would be a waste" to put houses on it.

Given the precarious nature of the milk industry these days, the family has occasionally considered what else the farm could produce. "For example," Mary says, "if Darryl's son decides at some point down the road he is going to farm, it might be that dairying won't be the profitable thing to be in. Maybe they will change to use the land in another way."

At present, it is doing well as a dairy. The "herd average," which is the amount of milk each cow produces per year on

average, is a very respectable 19,200 pounds. But just as the past seems so close to this farm, Flash sees the future not so far away, either.

I think that farms are going to be bigger, and only the more efficient operations are going to stay. I think you're going to see further erosion, particularly in the hill farms, where it's more difficult to make a living.

One of the things that may happen to the dairy farms in the valley is that they may be taken over by crop farmers. I think the vegetable people are really doing much better, and it may come to the point where the land is too valuable to put into hay and corn. That's one thing that does concern me, because I think that vegetable farmers are doing a much better job now than they used to, and they're getting more involved in marketing. I can see they've made a lot of progress in the last five or six years. . . . It means dairy farmers would leave. I don't know whether we could justify having this as a dairy farm if vegetable crops become much more valuable, because the returns per acre will be much greater in vegetables than they would in dairy.

This farm has adapted to the times. They started off in livestock and, I guess, beef animals. Then they went to onions, and then the onions became less profitable because they could be raised cheaper somewhere else. So they went to potatoes and tobacco. I think the sheep, during the Depression, saved the farm. They did very well in the sheep. It's just adapted to the times. Whatever is profitable is what they went into.

I don't think there's any big danger of corporate setups being successful in this part of the country, because I don't think you can beat a family farm. Families are committed. You can't hire people to commit themselves to that kind of efficiency. I still think that family farms have a definite place, not only here, but everywhere in this country. I don't think that there's enough profit for corporations to take over.

The Belden Farm story will follow a new course in the 1990s. In the last generation, family farms dominated the Connecticut valley towns. Now, Darryl and Lucinda find themselves virtually alone. None of their friends are farmers. "It gets frustrating fighting with suburbia," Darryl says. "You finish your week, and you think you've done pretty well. Then you talk to your friend, and because his job scheduling has gone to a four-day workweek, he gets three days off. Makes more money than we make in a week. You look at it and say, 'what am I doing?' I know in the end, I'm happy. But there are times when you say, 'Why continue to try and work against that?'"

I get a lot of satisfaction out of doing this. There are certainly days when I think I'm on a psycho path and belong in an institution. But I think everybody feels like that. I truly enjoy the animals, I really enjoy being outside. I feel very good when I can look at a field and think, "We accomplished that."

This is what I want to do. I hope circumstances will always allow me to be able to do this. I want this to be my life's work, and I want it to be profitable so I don't have to kill myself doing it, so I can truly enjoy it. Having a day off is a farmer's best friend, because that's when he can sit down and say, "Boy, I really like my work." Because you get to look back at it a little bit. Sometimes when you get into running fourteen or however many days straight, you wonder. But I'm very lucky. I can get a day off every now and then. That's when I can look back and say I really like this. If I worked thirty days in a row, I don't know if I could say that.

With his father's encouragement, Darryl involved himself with

the young farmers of the Agri-Mark dairy cooperative to mingle with other Northeast farmers his age. Darryl is president of Agri-Mark's "Young Cooperators." He and Lucinda attend regional and national conferences where they have learned how farmers in this part of the country must look beyond their own farms. As Lucinda says, they are forced into the political area of the agriculture enterprise.

Sometimes I think here we are, on our nice little farm, milking our cows, doing our work, every day is full, and the milk truck comes and picks up our milk and goes away. And every day the cows have to be milked again, and the cows have to be fed again, and we forget to just stop and look at the huge big picture of where the politicians fit in and where we have to write our congressmen. All the decisions about our lives aren't made by us. They are made by other people sitting behind big desks telling us how much we can get for our milk and telling us what they are going to do with the price of it. That can be real frustrating when we feel as if we don't have power over what we do. We just produce this milk and then there it goes. So it has been enlightening to be involved in the milk co-op so we can feel we have more say in how things happen. And even if we don't have an impact in how things happen at least we know how it happens, and how important it is to be politically involved.

Sustaining agriculture in Massachusetts and other New England states is a main aim of the farm organizations. Politically it has been difficult. The Cooperative Extension Service, which Lucinda's father succeeded in spreading to all reaches of Massachusetts at a time when the state had turned the corner into suburbia, is destined to be left by the wayside, yielding to private initiative the work of transferring new agricultural research to farmers. The federal government's role in upholding markets for agriculture has dwindled in recent years, especially in New England. State government's assistance to farmers has been reduced to sloganeering ("Massachusetts Grown and Fresher" is the marketing cry). The youth 4-H system, which the Belden family nurtured so well, and the county agricultural fairs are no more than nostalgic vestiges seen only in rural communities. But Darryl Williams in the Connecticut River valley expects to survive.

I really believe farms belong here. It doesn't bother me so much that the area is being built up, but that valuable ag land is getting used up. I go to enough meetings where I talk to farmers who farm on rocks to know that what we've got here is special. So I truly believe that agriculture belongs in Massachusetts. With the suburban population that there is in Massachusetts, there's always going to be an ample market for whatever we produce on this farm. I see that the prospects are good.

There will be some tight times, because the suburban population doesn't understand farms as much. The costs, taxes, seem to be higher here than in other states. As bleak as the picture is, I don't think they're going to let it go. I don't think anyone's going to let agriculture go. I think we'll always be here. And we're going to farm here, and we're going to make money, and we're going to do well. We're going to have to roll with the changes and roll with the punches, and we're going to have to fight a little harder on some of these tax issues. But by and large I think the people in Massachusetts support agriculture.

He refers to the grain embargo President Carter imposed on the Soviet Union in 1980, and the federal buyout of dairy farms now a few years old. These days, Darryl says, the federal government makes as many decisions for farmers as the farmers do for themselves.

In the future, farmers are going to have to go back to being more dependent on ourselves as a group, and less dependent on the government. We're going to have to take the initiative for that. The New England farmer typifies the independent farmer who is going to make his own decisions no matter what. But to an extent we are going to have to get more involved with our cooperatives, we're going to have to be more together. The only way I can see us surviving the next forty or fifty years is if farmers have the insight to come together and work together to see us through. We can't afford to depend on the government anymore.

When Darryl and Lucinda Williams talk about looking beyond their own farm, they talk very seriously. As Lucinda talks, Darryl rocks Rebecca in his lap.

The United States has the capacity to feed so many more people than we do. . . . There is starvation going on in our country. It is outrageous for me to think that they are paying people to let their land sit idle, to not produce things. They are paying us to produce less milk when there are people out there who don't get milk, who don't get the food they need. I think there is really something wrong here. Let's feed all our people and start feeding other people. We are all people. We all need to eat.

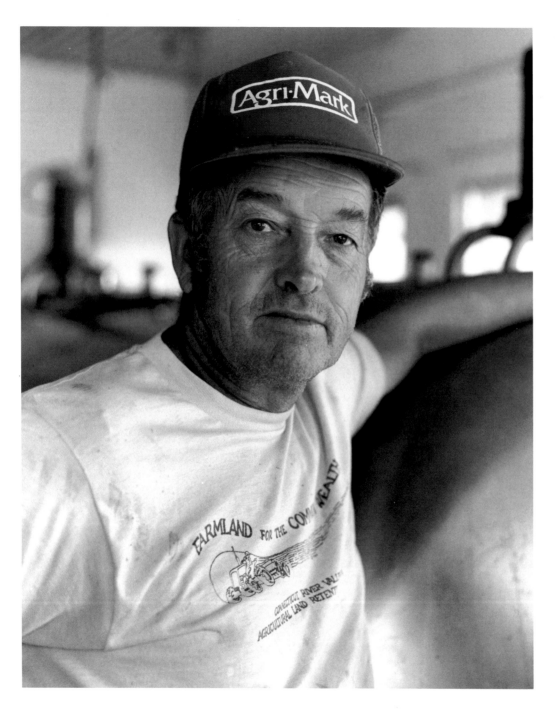

I think that it's just a matter of commitment. We're committed to keeping this farm going, as long as there's someone that wants to do so.
— "FLASH" GORDON WILLIAMS

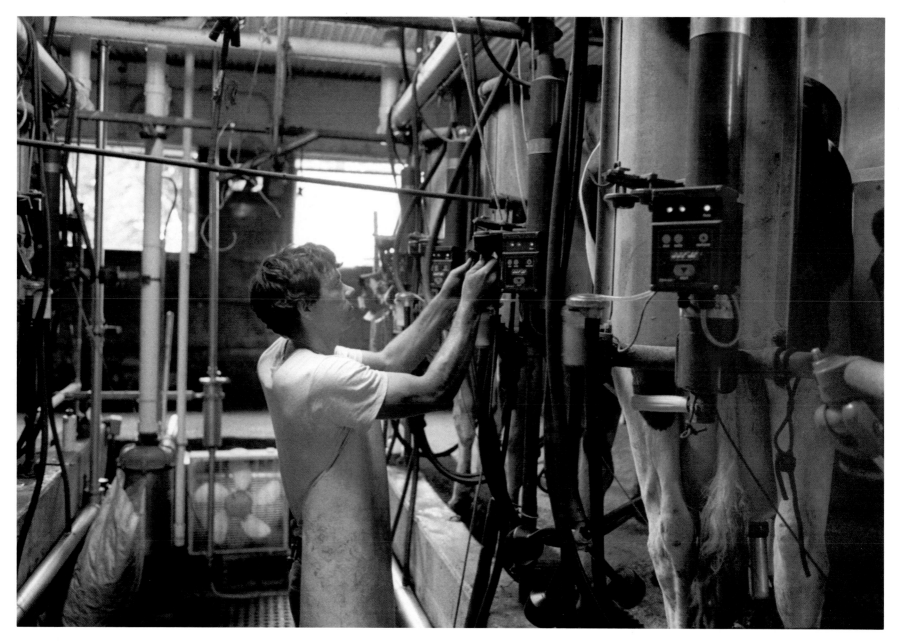

We can grow enough feed, plus sell some feed, and conceivably we could milk 100 or 150 animals mostly on this farm, and raise enough feed to do it.
—"FLASH" GORDON WILLIAMS

Evelyn Belden with classmates at her 60th Mount Holyoke College re-union in 1991. Mary was the "Class Baby" and Rebecca was the "Class Baby's Baby's Baby."

We had a big vegetable garden. Still do. That job is mine now. —EVELYN LADD BELDEN

I'm back to teaching part-time [at Clarke School for the Deaf]. . . . social studies and reading and speech and math.— MARY BELDEN WILLIAMS

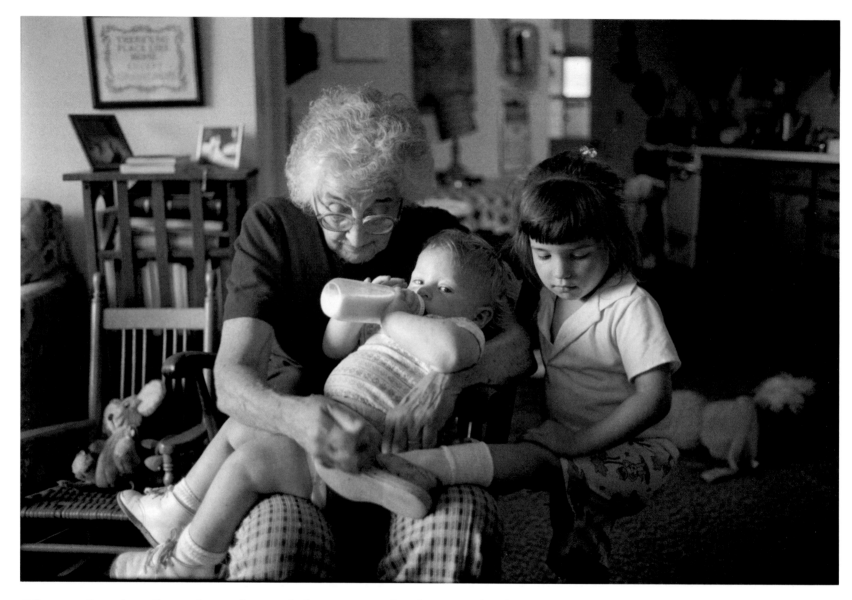

Often on a Saturday, after not having been with their great-grandmother since Thursday, the kids will ask, Rebecca in particular, "Now can we go over to Grandma's? I haven't been there in such a long time."— LUCINDA MCMURTRY WILLIAMS

It is a good way of life, and I think the kids will know that by growing up here. — LUCINDA MCMURTRY WILLIAMS

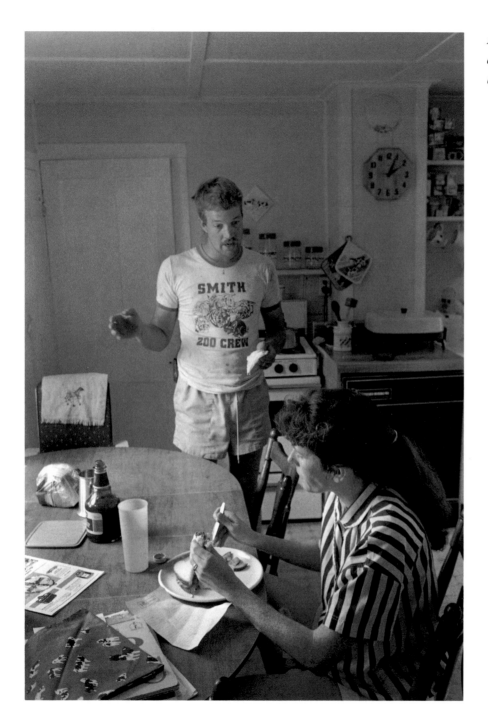

Every day I think how lucky our children are. [Darryl] is there every day for lunch and brings the kids home. And they love to be outside with him.—LUCINDA MCMURTRY WILLIAMS

With sewing and quilting, I start with a piece of material and when I'm done I have a beautiful dress or a nice quilt. . . . I feel a nice sense of accomplishment.
—LUCINDA MCMURTRY WILLIAMS

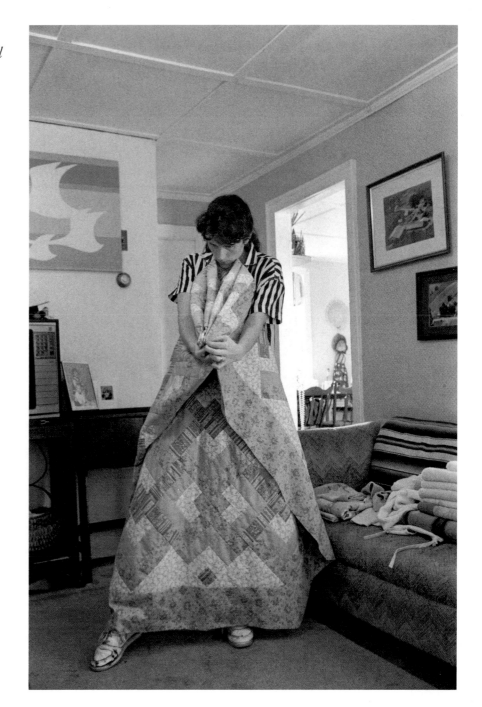

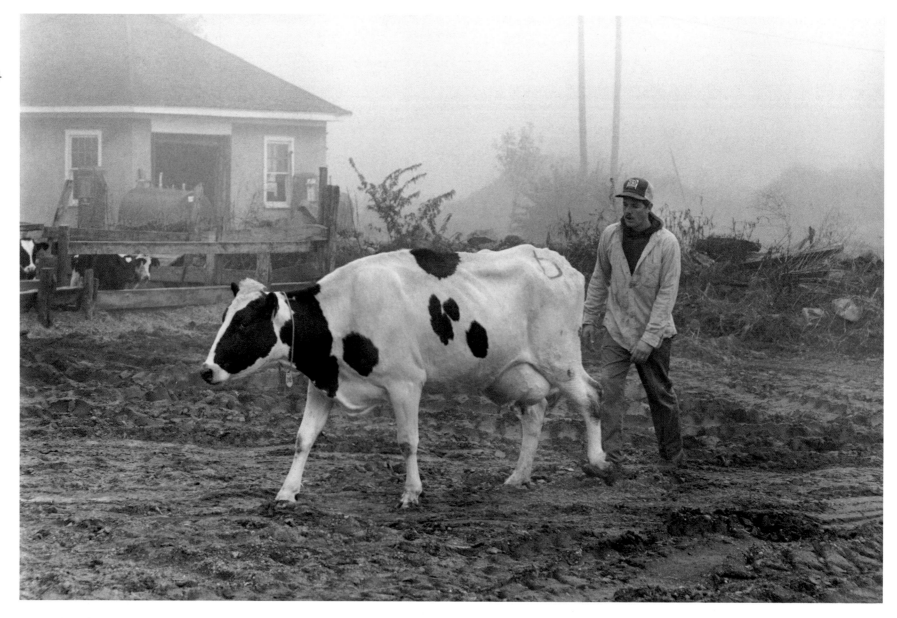

I get a lot of satisfaction out of doing this. . . . I truly enjoy the animals, I really enjoy being outside. I feel very good when I can look at a field and think, "We accomplished that."—DARRYL WILLIAMS

*I hope to provide an environ-
ment for my kids that will
allow them to choose. We
think it would be wonderful
if there were nine generations
on the farm. I don't want to
force them into it, but I don't
want to discourage them from
it.*—DARRYL WILLIAMS

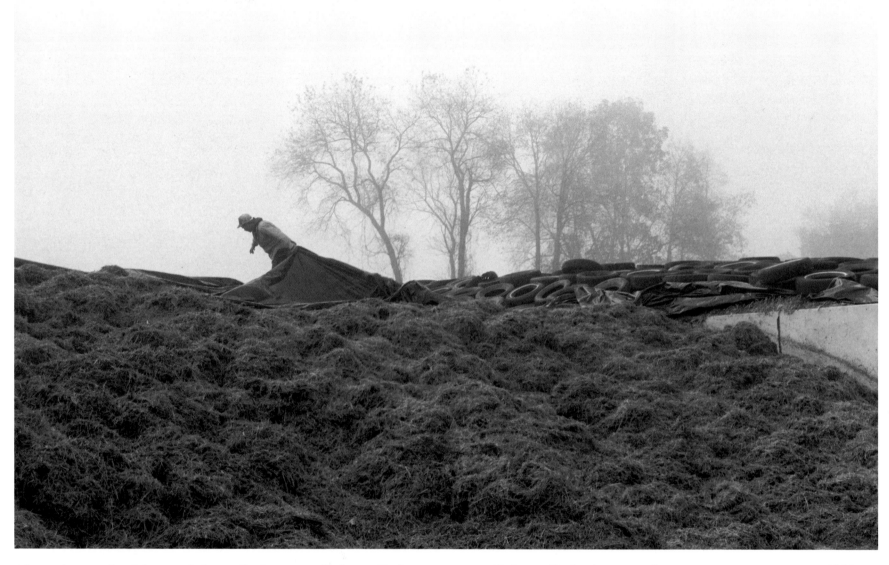

This is the same land that my father walked, my grandfather walked, my great-grandfather walked. It's grown tobacco, onions, potatoes, corn, alfalfa. The spirits of all those people are around here.—DARRYL WILLIAMS

This is what I want to do. I hope circumstances will always allow me to be able to do this.—DARRYL WILLIAMS

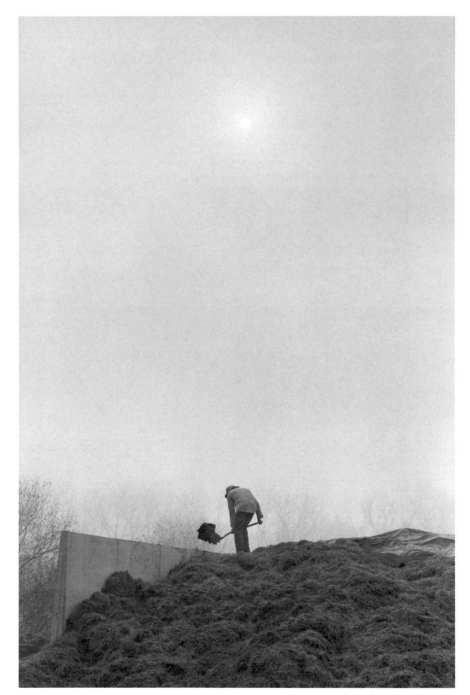

Wilbur Scott and his family began a dairy business in Buckland where they bottled milk and cream and sold it from a truck along a daily route in the Shelburne Falls area. The dairy business was called Sunnyside Farms, named after the Scott family place in East Hawley.

Scott Farm

HAWLEY
Founded in 1782

Jane Barnard Scott kept a diary of life at the Scott farm in Hawley in the middle and late 1800s. Some days she told of her husband, Thaxter, hitching a wagon to a team of horses and going to Shelburne Falls to buy grain for the cattle. Another day Thaxter and his son Wilbur would draw a sled of logs to sell in Charlemont. Once they hauled one big log to the neighboring Eldridge place where Eldridge sawed it to planks to repair the bridge at his pond. That was the neighborhood ice pond at the time. The farm families around Eldridges' cut ice there in winter, drew big blocks of it to the icehouses on their farms, and packed it away with sawdust. They used chunks of it in their kitchen iceboxes to keep food and milk cool and had enough to make ice cream in summer. "They swapped works," Jack Scott says today as he tells of the ice harvesting in his grandparents' life. "They would fill this icehouse today, the next one tomorrow, the third

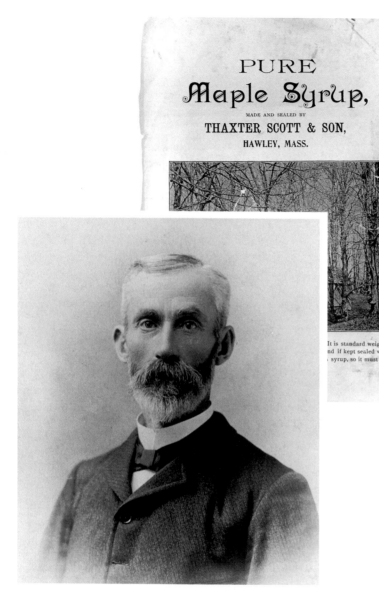

PURE
Maple Syrup,

MADE AND SEALED BY

THAXTER SCOTT & SON,

HAWLEY, MASS.

It is standard weight,
nd if kept sealed will
syrup, so it must be

*Thaxter Scott, grandfather of Jack and David,
great-grandfather of Raymond and Jim*

one the next day or two. It was cold enough that they got their icehouses filled by the third week in December. And it was *good* ice. *Cold!*"

In 1850, eighty years after settlers first came to the Hawley wilderness, the town had 881 people and 117 farms. There was some manufacturing going on, too — the most Hawley has ever seen. The biggest single industry was a shoe-leather tannery which produced some eighty tons of leather per year. There were also six sawmills, a palm-leaf hat industry which turned out 12,000 hats in 1850, three broomhandle shops, a cheese-box factory, and a blacksmith.

By 1870, Hawley's population had begun a decline that would continue for the next two generations. Of 108 farmers in Hawley then, the state census recorded that Jack Scott's grandfather Thaxter was one of about two dozen who farmed more than 100 acres and maintained more than $200 in equipment.

His grandfather, Jack says, continued some Scott family "English traits," such as whitewashing the cellar every year, and mixing manure fresh with soil.

You plowed land, spread manure on it for half a day, then you harrowed it to get the manure mixed with the soil. Today, people in big fields of corn spread all the manure for a week, and then it's time to plow it or harrow it, and it's laid there to the weather all that time. The English didn't do it that way, and neither did my grandfather or father. They harrowed it in the soil right away.

As he imagines the farm in those days, Jack can picture a subsistence life of producing milk, maple sugar, beef, chickens, eggs, garden vegetables, timber — enough to feed the family and sell products nearby. The children walked to a one-room schoolhouse or rode in a horse-drawn wagon if they were lucky. In

winter, farmers would plow snow from the roads to work off their town taxes.

The town of Hawley always has been as far away from anything as you can get in Massachusetts. Today only about 300 people live here, and the surrounding towns don't have many more people than that. A 1,900-foot-high mountain effectively divides the town into two main settlements, East Hawley and West Hawley, and it's a trek just getting from one to the other. It is a town of steep, rocky hills and woodland and small, fast streams. The town has no store, no gas station, no post office. Only during the past generation have new people settled here in any number, and they came mainly to live far removed from everything else.

"I have always said that the town of Hawley would be very different if the motor truck had come along sooner," Jack Scott says today. "The farms would have stayed. There were hundreds of them. They couldn't *be* more than subsistence farms. No one would come out here and pick up your milk."

When Jack was born in the East Hawley farmhouse in 1918, he was given the name Clark Scott, the family names of his mother and father, who came from two of the oldest families in Hawley. They called him Jack right away. He was the sixth of ten children and smaller than his older brothers—which allowed him to be overlooked if he decided to sneak out to do some fishing, and also allowed him to develop his reputation as "the quiet one." His brother David, three years younger, became "the yacker," Jack says.

The Scott children all were good looking. Jack today shows the same trim, handsome face seen in an old photograph of his grandfather Thaxter. Before he talks, he thinks, looking off somewhere, thinking. Then he talks in the deliberate, hillside Yankee cadence, clipping his phrases so you can finish them in your own imagination.

Dad could mow hay like you wouldn't believe. Used to bale hay with wire. Took two men to wire it.

In the late summer of 1923 when Jack was five years old, his father, Wilbur Thaxter Scott, and his mother Ruth Eleanor Clark, took their then nine children and left the farm in East Hawley that had been in the Scott family for 141 years. Wilbur was fifty-six years old. He was doing well enough as a farmer in East Hawley to buy a second farm down in the next town, Buckland, along the Clesson Brook, near where the brook runs into the Deerfield River. The second farm was closer to Shelburne Falls and the Mohawk Trail (Route 2). It would be easier to sell milk there. And the parents wanted the oldest son, Franklin, to attend high school at Arms Academy in Shelburne Falls.

They began a dairy business in Buckland where they bottled milk and cream and sold it from a truck along a daily route in the Shelburne Falls area. The dairy business was called Sunnyside Farms, named after the Scott family place in East Hawley.

The Scott place in Hawley is as pretty and as simple as they come. Stone walls border the broad fields and pastures. Its woods contain ancient maple trees and oaks and tall, dark pines. The farmhouse and barn, painted all yellow as people now remember, seemed to shine there on the south-sloping open land. You can walk up into the high mowing behind the farmhouse and look for miles to the south, east, and west and see only hillsides and forests. Once in a while a car or truck passes on the road out front.

When Jack was growing up, the family came here mostly in summers to mow the open land and to pasture the heifers. In the 1930s there were ten children in the family, most of them in school in the North District schoolhouse in Buckland and at

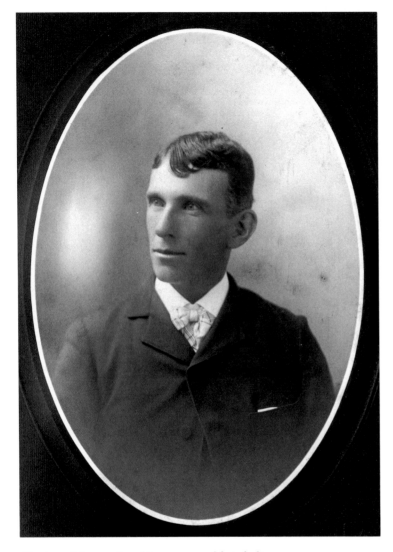

Dad could mow hay like you wouldn't believe.
— CLARK "JACK" SCOTT

Arms Academy in Shelburne Falls. They would do chores at the dairy farm mornings and after school. In summer they worked all day, Jack remembers. "If they could find me," he adds. "I couldn't see any reason why I couldn't *fish*. Or walk in the *woods*."

Invariably, though, Jack would be there with some of his two older brothers and three older sisters, or his two younger sisters and two younger brothers. They would ride the hay wagons early on those summer mornings, drawn by horse team over the hill beyond Buckland and into Hawley. The horses seemed more content once they crossed the town line into Hawley, where the roads were not paved. The family would stay all day mowing and pitching hay onto wagons. They kept some hay in the Hawley barn and took the rest down to Buckland in the evening. Jack's mother and sisters worked in the garden and kitchen. The girls often stayed the night at Hawley and had breakfast for everyone as they returned the next morning.

Kathryn Scott Flagg, the sister just older than Jack, remembers haying with the horses — Dudley, the driving horse, and Prince and Dick, the workhorses. Now a retired teacher in Millers Falls, Kathryn writes of riding in the hay wagon while a brother or sister spread the load:

One of us children trampled the hay on the wagon as the tumbles were pitched up to the loader. The load of hay rose higher and higher until I would become leery of falling over the edge. That never happened, but after the ride to the barn, the way down was to slide as far as the evener behind Dick, where I could rest a hand on his solid rump, and then make the easy jump to the barn floor. Later the haymows were treaded to gain space for more hay. Any of us older children, weighing from 50 to 100 pounds, could help settle a haymow.

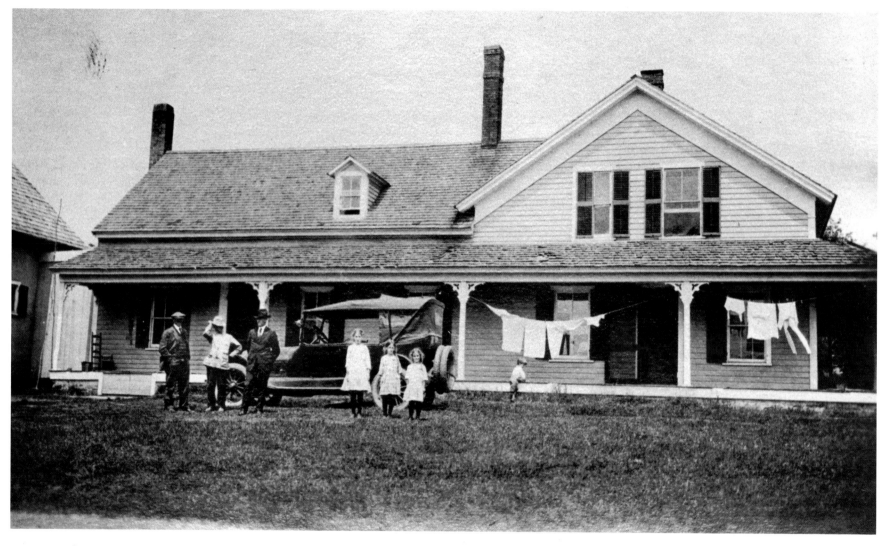

Visiting relatives at the Scott place in the early 1920s. Jack Scott stands under the clothesline.

Also I remember watching Dad guide Dick, who probably weighed almost a ton, onto the middle bay at the second-floor level. With a fine combination of trust and caution, Dick stepped from the heavy timber surface to the jouncy haymow, allowed himself to be led back and forth many times, and returned to the floor. Dick was equal to anything!

For a few seasons, Jack's older brothers, Franklin and Darwin, drove a horse team from Buckland to East Hawley in late winter and early spring to gather sap and make maple sugar and syrup in the sugarhouse as their grandfather Thaxter had done.

Boys at the Arms Academy high school in the 1940s studied agriculture in addition to reading, writing, and arithmetic. Ag was the one course which suited Jack. He especially remembers his agriculture teacher, John Glavin. Otherwise, when discussing high school at Arms Academy, Jack says, "I was exposed to it."

John Glavin. Now there was one smart man. If he hadn't been a Catholic, I think he would have been head chief at the Academy. He was an institution all his own. He taught the agriculture class for a good many years. He would come out to the farms. We had school projects going at the farm. . . . One time he came up to look at the place in Hawley. He wanted to see it. "This would be just right," he said. "Stay right here all week, and go to market once a week." He thought that was about as nice as anything could be.

Thinking of the years on the Hawley and Buckland farms, Jack stresses that "this is just the way I remember it." There were many points of view in the extended Scott family. He knows his father was a good farmer, "but I didn't always see eye-to-eye with him about what he had in mind." And he pronounces it slowly, "oy to oy," and "had in mo-ind." Then he grins a little.

We couldn't have tractor. Tractor wasn't good. It would pack the dirt all down. Well, we did have one while he was alive, but he didn't like it much.

We boys had trucks. Dad didn't think much of trucks. We put sideboards right on, a tailgate. Hauled cattle in them, used them for logging. One of the trucks we had went to Brighton stockyards. Every week. Milk cattle, veal, pigs, anything we had.

When Wilbur Scott died in 1946, Jack was twenty-eight. The oldest boy, Franklin, had died a few years earlier. Darwin had gone to their Clark grandparents' farm in Longmeadow. So Jack ran the Sunnyside dairy in Buckland with his mother, sisters, and the youngest boy, Richard. David, who was twenty-five and recently out of military service when the father died, decided to move onto the East Hawley place.

Jack and Richard managed the Buckland farm until the middle 1950s, when that place went to Richard and his family. Jack became a logger and bought a farm in another town, Montague. He did not return to Hawley until 1987, when he and his wife, Elvira Bellows, retired to land her family owned in East Hawley. By that time, Elvira had taught school thirty-four years in Athol and Jack had worked twenty years in a Brattleboro, Vermont, paper mill. "Seems to me someone should be allowed to make a living at what they like to do," Jack says. "But it doesn't always work out that way."

As Jack recalls it, David wanted to take over the Hawley farm once their father's estate was settled. "So everyone signed off and let him have it." David eventually bought the place from the estate in 1950.

* * *

The first David Scott to settle in this territory was Thaxter's great-grandfather. He lived in the Connecticut River valley town of Whately in the mid-1700s. The Scott family had been in the valley since the seventeenth-century days of the English settlement in western Massachusetts and had achieved some prominence. An 1887 historical account of Hawley by William Giles Atkins says, "David Scott of Whately, known as 'Master Scott,' was a man of great originality, a farmer, and a carpenter, also a great hunter. . . . [He] possessed many sterling qualities. He originated the square rule in lieu of the old 'try rule,' formerly used for framing." The family acquired land in the Hawley area when it was unincorporated and known as Plantation No. 7.

David's son Phineas was the first Scott to come to Hawley to live. Soon after his service as a soldier in the Revolutionary War, Phineas journeyed to the Plantation No. 7 territory and built a log cabin on southeast sloping land. He covered the roof with bark. He returned to Whately to fetch his wife and infant daughter. In the winter of 1782 they loaded their furniture and farming tools on a sled drawn by two steers and, with the family cow, they trudged through a snow so heavy they reached only the next town the first day. Local settlers, the story goes, helped the young family through the snow. When they reached Hawley, accumulated snow had collapsed the roof of Phineas's log cabin.

The cellarhole of that log cabin is visible alongside a wood's road that runs through the Scott farm's sugarbush and pine plantation. Thaxter built a maple sugarhouse down there. And after David moved here in the early 1950s, he would take his own young family to the cabin site and tell the story of his great-great-great-grandfather Phineas, the third settler of Hawley. When asked by a newcomer recently why his family settled in Hawley, David Scott said, "I don't know. You'll have to ask my great-great-grandfather."

David's move to the Hawley farm was not much easier than his ancestor's even though the house and barn already were there. Having served mostly as a summer mowing and pasture, the farm was not exactly outfitted for a young family to go directly into business.

In 1947 David married Ellene Anderson, who grew up in the adjacent town of Ashfield. They first lived in a rented apartment in Ashfield. David worked driving a milk truck, and he helped on some local farms. When they had time, Ellene remembers, they would go out to Hawley and try to fix a few things on the house. They mowed in summer. It took them about four years before they could move there.

When we bought the farm, it was very run-down, so we had a lot of work done on the inside. Put in a well for water, a heating system, electric lights, a telephone. We had dirt roads. And in the spring, the mud was so deep, we couldn't get through. Finally, hardtop came.

There was wide old floorboards in the house that were pretty well gone, so we gutted it all and built it right up. We'd come up here and it was just plain runners that we walked on.

We cleared the fields up there. They had a well up in the field, so we filled that full of rocks. Didn't want the kids getting into it. At that time, we only had Raymond, our oldest son.

Finally, we moved up. Sheila was born in 1953, and we moved up in 1954.

I moved up January first, when the house was more or less completed. The heat was here, the lights were here, the water was here, but no telephone. They didn't have a telephone in those days, not even

a crank. So I came up in the back of a truck, holding up a refrigerator and a couch. My introduction to Hawley. New Year's Day, January first. It was a van, like. Every time we went uphill, everything would slip backwards.

Ellene speaks affectionately of her husband, "Scotty," as he came to be known to some. He worked hard and was often away from home when the children were young. Raymond was old enough to be helpful, Sheila was a toddler, and Jim, the youngest, was born in 1960. Ellene remembers some lonely times in Hawley in the 1950s.

Scotty went on trailer trucks, and I was here all alone with Sheila and Raymond. He was driving trailer trucks for potatoes. He'd go clear to Florida. He might go up to Canada for window supplies. I didn't know any neighbors. I used to wave to the mailman. Every morning he went up at nine o'clock, and I'd wave to him. Then he'd come back at noontime. I'd wave to him. He finally stopped, about a year later, with a package and I said, "Gee, sir, I'm glad you're someone to talk to." I said, "I'm here alone. That's why I wave to you when you go by."

Gradually the Scotts revived the farm. They leased pastureland to a local dairy farmer. They kept one milk cow and a steer for beef. They set 500 taps in the maple sugarbush and trucked sap twelve miles to Cummington every evening during maple season to be boiled down. In summer they picked blueberries that grew various places on the farm and put them out in quart baskets on a table by the roadside. And, of course, there was all the hay every year. Ellene says those were days when neighbors would come to help at haying time.

The neighbors all pitched in one night. Scotty was gone on a trip, and a thunderstorm came up. So the neighbors happened to be riding by, and they all stopped and helped to pitch on the hay. We got it in the barn just before it got wet. But it was lightning all around. They stopped in. We could get the neighbors to help. Like if I ever had a fire or needed the neighbors for anything, they'd always come. I don't know as they do that so much anymore.

Ellene for years cut greens in the woods and made Christmas wreaths to sell. In the early years, she and Scotty earned extra money in the fall loading and trucking Christmas trees and greens.

We would go up to Vermont and load baled brush, and we took it to the city, New York City. It was baled Christmas greens. You've seen bales. And we'd tie up big Christmas trees, and we'd take them to the city. Scotty and I and other trucks would take them down.

We didn't cut them. Different farmers up there would. They'd drag them out of their woods by a tractor or horse, maybe, and then they'd have it all in a big long row. The trailer trucks would come and they'd back in and start loading on the bales. . . . And at the end of the row, there was always a jug of corn liquor. The very last bale. That was your little reward for getting all scratched up and all covered with pitch and everything else.

You started at the bottom of the Christmas tree, and you wrapped it with string, and it was—oh, it was cold, they were covered with snow, soaking wet,—'til you got up to the very top, and they lifted it and put it on the truck. There were several men that helped with lifting the bales. The men loaded them on into the trailer, and we bound it down with chains. Good, big trailer trucks. I used to go with them.

By the middle 1960s David Scott had a contract for driving a

school-bus route to the new regional high school in Shelburne Falls. He would be gone an hour-and-a-half in the morning and again in the afternoon, giving him much more time on the farm than he had while driving trucks. The family began raising calves for the big Wauban Farms dairy in Ashfield. They hayed the fields. David harvested some trees to sell as lumber. The children could help after school and in summer with the livestock, and with the blueberries and maple. It was always a struggle, Ellene says, but it was fun, too.

At first we had a horse, and I used to ride the dump-rake for haying. One time I was down in the field. I had the two reins, sitting on the dump-rake. Well, anyway, I lost one rein, so I only had my right hand. Well, he had on blinders, and that horse just was going around in a circle. And all of a sudden, when he came around this way he saw what happened. I didn't dare jump off that old rake. I clung onto that seat for dear life, and that horse ran all the way from down there in the middle of the field, raced up and finally stopped at the barn.

Was Scotty mad! I said, "I'm not ever going to get on that dump-rake again, not ever." And he says, "You get right back on it, hold the two reins." He says, "You're not going to let this get the best of you." So then I'd get so nervous, I dumped a big pile of hay here, another one there. Then he'd come along with a pitchfork and try to roll it up into a mound. It's down underneath the toolshed, the old dump-rake. I don't ever want to see that again.

We had Jim out there on a little sled when we were out there sugaring, and he'd ride on that little sled until finally he got sick of it and toddled around in the snow. We were always pulling him out of some drift.

There is a catwalk up high in the barn about two or three feet wide, and the hay was up on the high part of it. And Raymond had to bring the hay down and drop it down into these long troughs so the cattle could come and eat. That was quite a little task for Raymond.

And every morning and every night they had those calves that were in the barn. The babies all had to be let out for water, each little pen at a time, and hooked up again after they'd had their grain. And let back in.

Raymond didn't complain too much. I think, you know, when children do it day in and day out, month in, month out, it does get tiring. Anything like that gets tiring, but a lot of days when Raymond might have wanted to be gone, then Scotty would stay home and do it all.

David Scott became a leading public figure in Hawley in the 1970s. He held the transportation contract with the regional school, he kept as many as 200 young cattle on the farm, sold sap and wood, and dedicated himself to community service. He was a selectman and town representative for military veterans for about twenty years. He was the town fire chief.

In the summer of 1985, the U.S. Air Force notified Hawley of its intention to erect a radio transmitter station on 600 acres of Hawley potato fields, including land owned by David Scott. It was a high, remote place, the Air Force figured, and the facility's thirty-one antennas, ranging from 240 to 300 feet tall, might not bother people. David Scott, "the yacker," as his brother called him, steadfastly opposed the field of antennas. "Our land down the road here has been in our family for 203 years," he told Ken Kipen, who interviewed him for the Ashfield newspaper. "If the Air Force has nothing better to do with it than put up some towers . . . I say let 'em use a pony express instead. It'd be plenty quick enough." His joining the very forceful local campaign to "Save the Hills" at that time helped persuade the Air Force to

look elsewhere. By autumn, the Air Force and its thirty-one-tower antenna farm was history.

About a year later, on the evening of November 18, 1986, an early blizzard of snow surrounded Hawley. David was returning home in his pickup truck, and he decided to stop, get out, and attach a set of chains to the tires. It was something he wouldn't think about twice. He would just stop and do it. As he worked, the truck fell onto him and killed him. The Scott family, the town, and the farm abruptly lost their head man.

*　　*　　*

Today, Jim Scott, who is thirty, does what his father did when he was Jim's age. He works at a job off the farm hoping that someday he'll be ready to farm the place full-time.

Jim, in fact, works two outside jobs. He works all day in a sawmill in Williamsburg, twenty miles away. After the sawmill work, and on weekends, he delivers sawdust to farmers. He is up at 5:30 in the morning and returns home to East Hawley at 8:00 or 8:30 in the evening when he feeds, waters, and tends the calves he raises. In spring he takes three or four weeks off from the sawmill and sets 4,500 taps in maple trees to collect sap he sells to a maple sugar operation in Deerfield. When he has a chance, he cuts firewood for the family and he may sell a few cords to neighbors. And he's trying to build a house for himself.

Jim lived in a small trailer while beginning to build his house on the two acres of the family farm property he bought recently. Now he rents the trailer and lives in the main house with his mother and older brother, Raymond. Raymond, who has difficulty seeing, is forty and takes care of lawns in the Hawley area.

Raymond also works at the farm, but he is not as interested in assuming the business as Jim is. Their sister, Sheila, now thirty-eight, works at an insurance firm in Greenfield thirty miles away and lives with her husband on their ten acres of the farm.

Jim realizes the size of the undertaking he has before him, to maintain the eighty-five-acre farm, then establish it as a going concern. He and Sheila and Raymond and their mother do not want to dissolve the farm into building lots or anything else. Jim is indomitable in his resolve, in his way of doing things. He is very serious, soft-spoken, reserved. He simply goes about his work.

Any money I get I put into the farm, if I can. To get more calves or something. Then I can sell the calves to get money I can use to buy something else for the farm. I just want to keep getting bigger and bigger here until I can afford to do it. I don't plan on working forever at the mill. My father worked out when he first started.

I could probably leave the sawmill now, but I don't want to have to take a loan out and risk it, getting halfway through and have to sell out something. This way I can do it on my own. I can pay for everything right then and there. At least I'm still using the farm. It's not as big as it was, but I'm doing it on my own. The bank doesn't have a loan over my head. I have one on my house, and that's enough.

The old barn and pasture next to the house are home to Jim's calves, anywhere from ten to thirty of them at a time. They live there eighteen or nineteen months until they are ready to go to a dairy farm. Jim lets a radio play for them in the barn in winter, just to keep them happy. He also raised a steer for family beef this year. Last year he raised a few pigs, but found he really didn't have enough time to care for them.

Ellene Scott's friend, Hattie Clark Fuller, has childhood memories of the Scott farm. Hattie Clark's father grew up in Hawley and was a cousin of Ruth Eleanor Clark, the mother of Jack and David Scott. When Hattie would come to her grandfather's place and pick blueberries in summer, she would look off and see the Scott farm in the distance. "It was this beautiful farm, all yellow, big, with a porch," she says. "We wondered where this place was. It looked like a castle, you know. Then as I grew older and traveled this road, I learned it was this place. I would ask, 'Is that the place?' Even as a child I was impressed with it."

As she talks with Ellene today, Hattie has her own ideas of what has happened to nearly all the farms of Hawley. Most people can't afford to keep them, especially if they need help with the farm work.

It's changed now to where people have to go out to work to earn the money in order to pay taxes. It can't be so much on an exchange scale anymore, you know, where one depended upon the other to help one another. You used to be able to survive pretty much by yourselves with your own potatoes and vegetables, as long as you had some food in the house. Men could do their work. What one person might have, another person would exchange for, years ago but not now. Now you're talking about families that are not necessarily farming anymore, and they've got to find money. They've got to have more money. You can't survive on a farm. So they can't spend the time to help *you farm, to keep* you *going. There's no exchange anymore.*

With help from his mother, his sister and her husband, and Raymond, Jim believes the Scott farm will remain. There are cousins, too, children of Jack and David's sisters, who care what happens to this farm. For now, Jim just wants to try it on his own. The place has endured its share of hardship, extending from that winter of 1782 when Phineas was here rebuilding the cabin whose roof had collapsed. The stretch of time and the six generations between that winter and the winter of 1990 when Jim Scott played the radio in the barn for his baby calves, however, does not seem especially significant, or burdensome, to this family. It's as though the continuity simply is expected. No one really knows why the Scotts moved here in the first place so long ago. As he gazes at Phineas's cellarhole, Jim ponders the life of his eighteenth-century grandfather and does not consider it so much different from his own.

I guess their roof caved in while they were bringing their animals up. From what I can understand, they had a lean-to for their animals. I don't think they had a barn.

Then they moved it all up there. We're not sure why. Whether it was just for the winter, or they changed their mind, realizing it might have been hard to get out in the springtime or not.

You wonder why they decided to move here in the first place. Maybe because land was cheap, and it was getting crowded down where he was. Maybe he wanted some privacy.

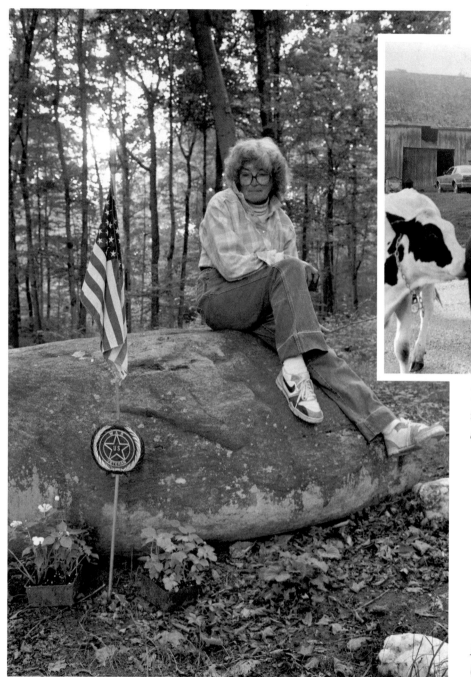

The young stock, we raised them from little baby calves right up to breeding. . . . Along toward the end, [David and I] had over 200 here.—ELLENE SCOTT

Ellene Scott's memorial to her husband David A. Scott (May 5, 1921 – November 18, 1986)

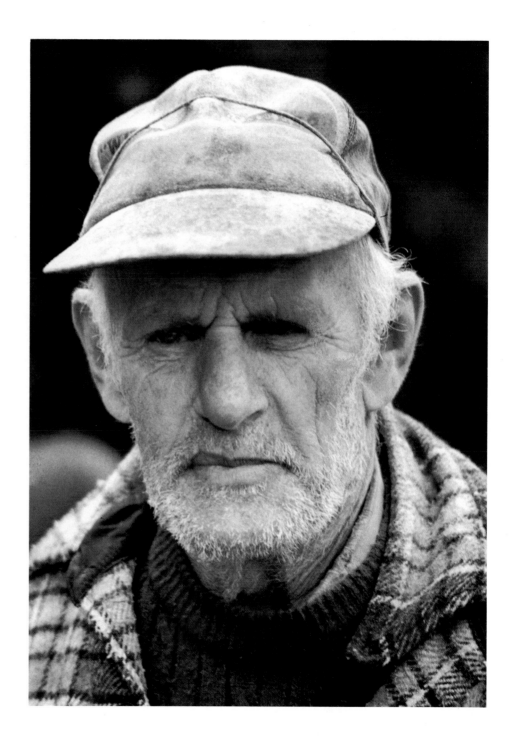

David Scott in 1985, about a year before he was killed.
(Photo by Ken Kipen)

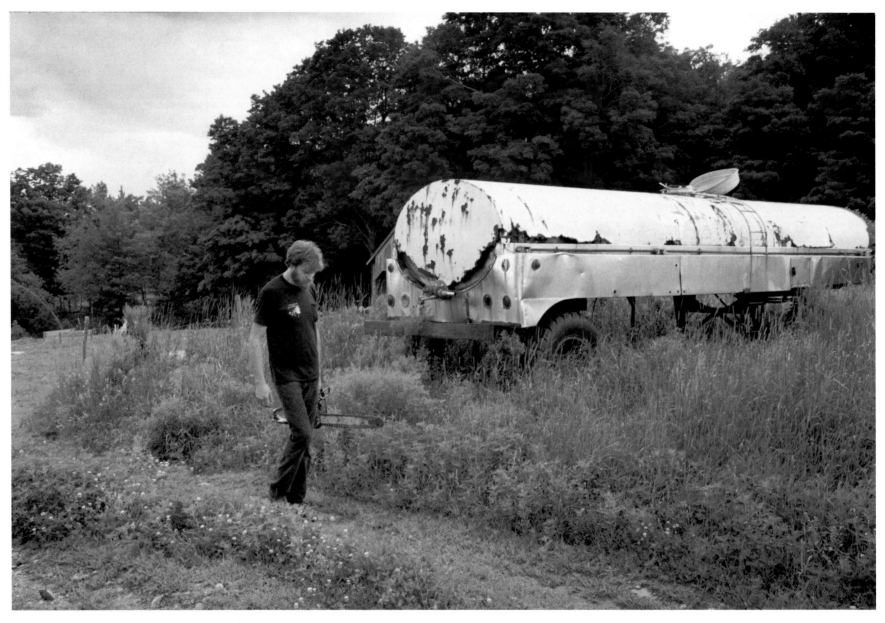

This is a road I'd use up through here with a farm tractor, after I got my chores done and the day was my own. I'd go out and get firewood out so I'd have income, too. — JIM SCOTT

We used to come down here to get pine cones to decorate Mother's Christmas wreaths. She would make them and sell them.
— SHEILA SCOTT CHAFFEE

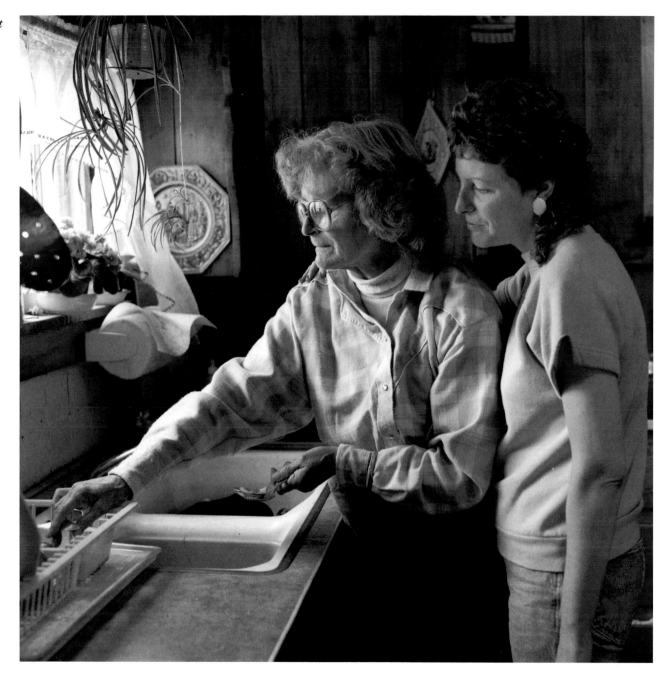

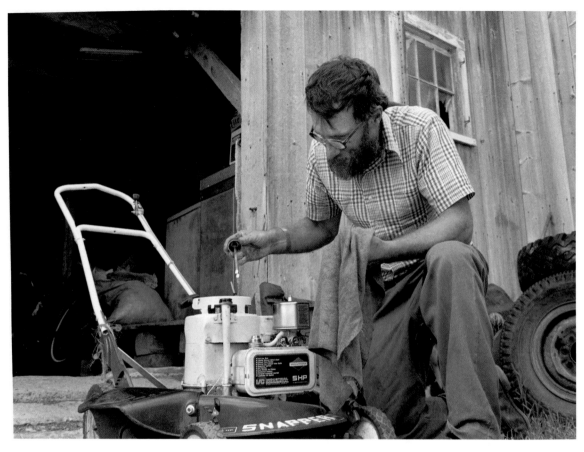

Raymond has his lawnmowing business in summer.— ELLENE SCOTT

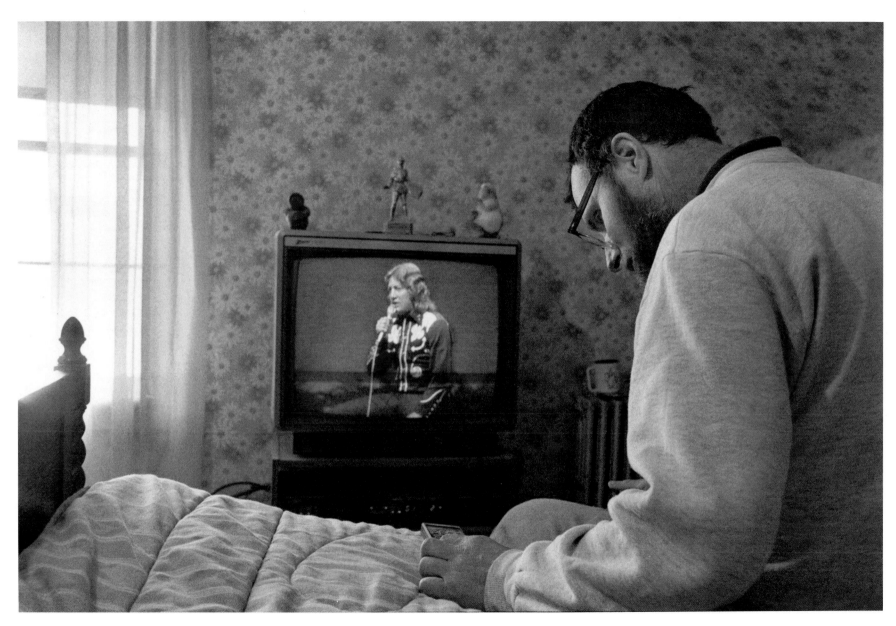

Raymond is proud of the sophisticated television system he has arranged in his room.

In spring Jim takes three or four weeks off from the sawmill and sets 4,500 taps in maple trees to collect sap he sells to a maple sugar operation in Deerfield.

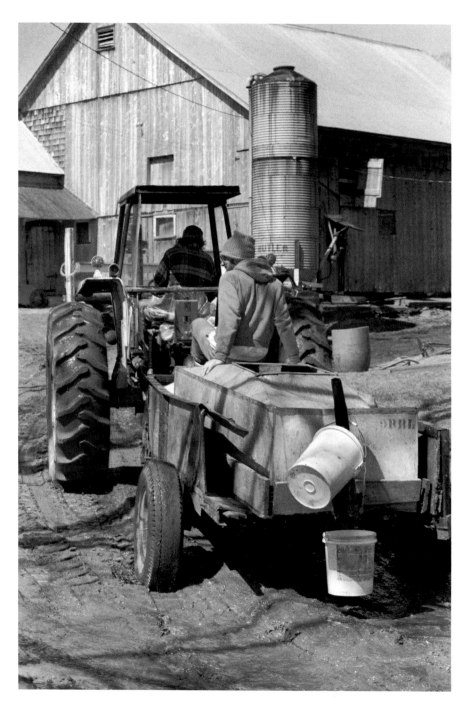

OPPOSITE PAGE:
Jim collected some 35,000 gallons of maple sap in the spring of 1991. He said the run was high in volume and low in sweetness.

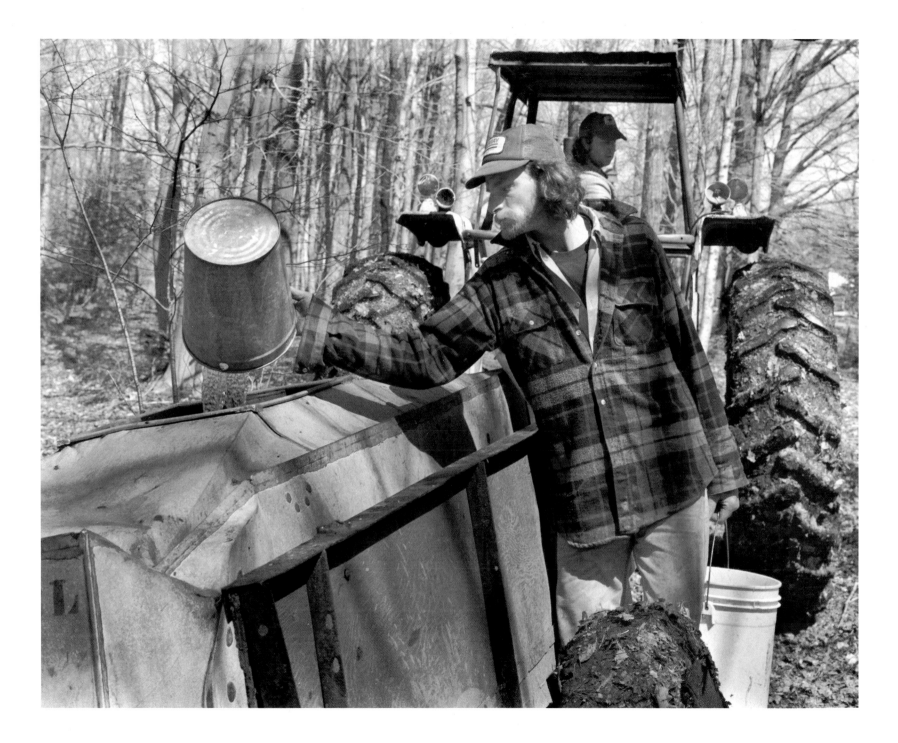

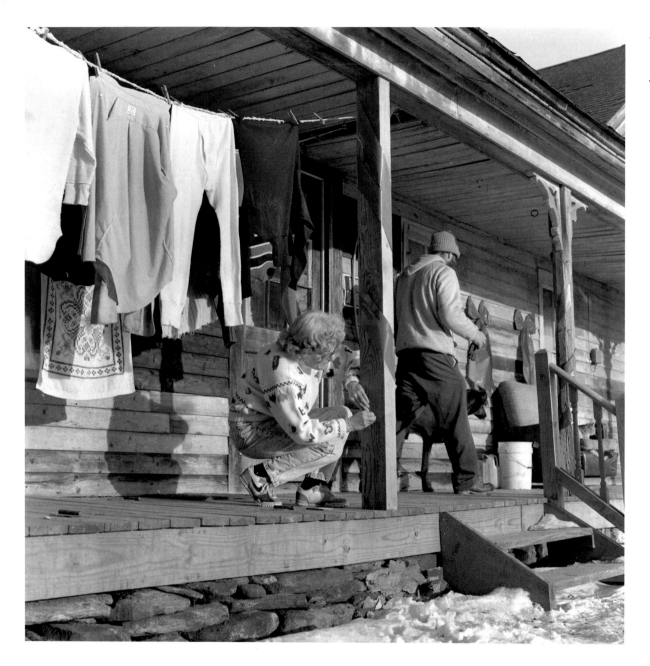

Almost always we were just the kids and Scotty, unless we could get someone to help us, which wasn't too often.
—ELLENE SCOTT

We spent roughly three years getting the place ready.
——ELLENE SCOTT

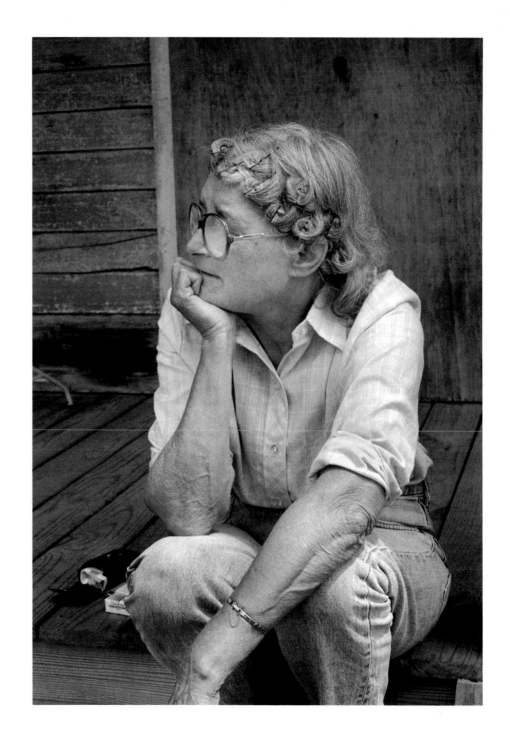

At least I'm still using the farm. It's not as big as it was, but I'm doing it on my own. —JIM SCOTT

You wonder why they decided to move [here in 1782]. Maybe they moved here because land was cheap and it was getting crowded down where he was. Maybe he wanted some privacy.
—JIM SCOTT

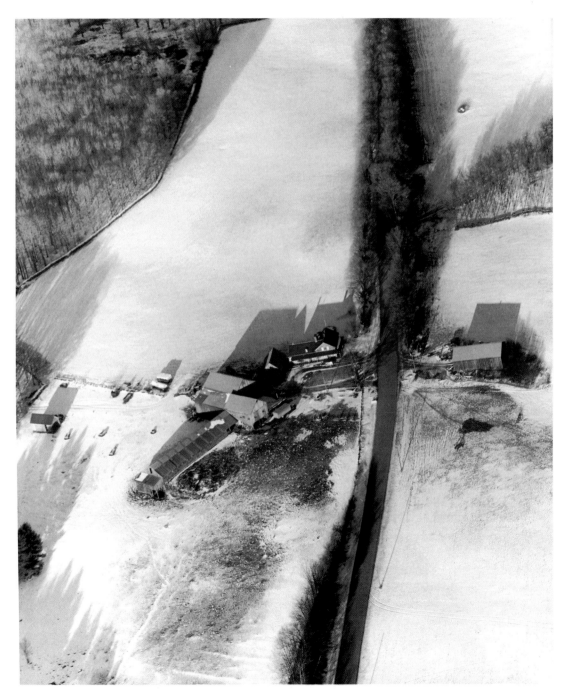

131

They would ride the hay wagons early on those summer mornings, drawn by horse team over the hill beyond Buckland and into Hawley. The horses seemed more content once they crossed the town line into Hawley, where the roads were not paved.

SOURCES

Atkins, William Giles "History of the Town of Hawley, Franklin County, Massachusetts, From Its First Settlement in 1771 to 1887, with Family Records and Biographical Sketches." Published by the author, 1887.

Bailey, Sarah Loring. *Historical Sketches of Andover (comprising the present town of North Andover and Andover), Massachusetts.* Houghton, Mifflin and Co., 1880.

"Belden Farm History." Private papers of Evelyn Belden, 1986.

Bromfield, Louis. *Early Autumn: A Story of a Lady.* Frederick A. Stokes Co., 1926.

Chase, Charlotte Moulton, Pauline Chase Harrell, and Richard Chase. *Arrowhead Farm Through the Centuries and Seasons.* The Countryman Press, 1982.

Flagg, Kathryn Scott. "Highlights From the Past: Halcyon Days in Hawley." *The Edge of Hawley.* Sons & Daughters of Hawley, Inc., January 1991.

Geiger, James S. *Appleton Farms, 1638-1988: A Brief Agricultural History.* Published by the author, 1988.

Greven, Philip J., Jr. *Four Generations: Population, Land, and Family in Colonial Andover, Massachusetts.* Cornell University Press, 1970.

"In a Yankee Valley." *Country Gentleman* (July 1947).

Klinkenborg, Verlyn. "The Thousand-Acre Backyard." *New England Monthly* (July 1989).

Massachusetts Founding Farms: Cultivators of Our National Heritage. Massachusetts Department of Food and Agriculture, 1988.

Merrill, Lorraine Stuart. "Appleton Farms' Composting Venture." *New England Farmer* (October 1989).

Parker, Harrison. "Hawley's Farms and Industries, 1850-1870." *The Edge of Hawley.* Sons & Daughters of Hawley, Inc., July 1983.

———. "Hawley's Loss of Land to Plainfield in 1803: The Story of a Dispute Which Influenced the Incorporation of Both Towns." Draft monograph, Historical Commission of the Town of Hawley and Sons and Daughters of Hawley, Inc., December 1989.

Tharp, Louise Hall. *The Appletons of Beacon Hill.* Little, Brown and Co., 1973.

Waters, Thomas Franklin. *Ipswich in the Massachusetts Bay Colony,* Vol. 1 (1633-1700) and Vol. 2 (1700-1917). Ipswich Historical Society, 1905 and 1917.

ABOUT THE PHOTOGRAPHS

My approach to my work has roots in several historical movements. The Farm Security Administration photographers during the 1930s (Dorothea Lange, Walker Evans, Russell Lee, among others) produced an important and sensitive documentation of rural life in the United States. "Candid" photographers such as Helen Levitt, André Kértész, and Henri Cartier-Bresson infused photojournalism with poetry, grace, wit, and spontaneity. I value both of these traditions and hope that my photographs of Massachusetts family farms exhibit some of these qualities.

Many of the photographs in this book are portraits. I try to depict universalities as well as intimate personal details. My goal is to establish a connection between the subject(s) of the photographs and the viewer: a shared understanding or even a conversation.

I work in black and white in order to convey both design and composition as well as the emotional and social elements of the photograph.

In seeking the "truth" about these farms, I realize that each of the photographs is my own interpretation. But the subjects themselves tell me that these interpretations accurately depict their lives and values. I hope that the photographs will promote understanding and stimulate discussion of the contemporary family farm, its place in our history, and its role in the future of farming in New England and in the United States.

Stan Sherer

ABOUT THE AUTHORS

Stan Sherer is a Northampton resident who has photographed in this country, Europe, the Caribbean, the Middle East, Africa, and the Philippines. His work has appeared in a variety of publications in the United States and Europe. As a Copeland Fellow at Amherst College in 1988, he photographed the people who participate in the agricultural fairs of western Massachusetts, at work and at home; this resulted in an exhibit entitled "Fair People: Continuing a Tradition." He is currently working on a documentary about the closing of the Northampton State Hospital and on a portrait of contemporary life in Albania.

Michael E.C. Gery is a writer and editor who since 1974 has concentrated on rural community life. Until 1991, he lived in Ashfield, where he worked with the monthly newspaper, produced publications for the historical society, and was moderator of the town meeting. His work has appeared in regional and national magazines. He is now associate editor of *Carolina Country* magazine in North Carolina and is working on a documentary of the Cape Hatteras National Seashore.

For six years, in addition to pursuing special projects, Stan Sherer and Michael Gery collaborated as photographer and editor of *The Campus Chronicle,* the weekly newspaper of the University of Massachusetts at Amherst.